M000318067

IMAGES
of Rail

SAN FRANCISCO'S
POWELL STREET
CABLE CARS

The sprit and flavor of the Powell-Mason cable, Powell Street's most enduring and arguably most important cable car line, is captured in "The Song of the Powell Street Grip," which was printed in the Market Street Railway's *The Inside Track* of March 1923. The poem parodies Gelett Burgess's 1901 poem "The Ballad of the Hyde Street Grip," which describes the California Street Cable Railroad's O'Farrell, Jones & Hyde cable. The author is unknown. (Courtesy Bob Townley.)

Song of the Powell Street Grip

Oh, the rain is slanting sharply, and the Norther's blowing cold,
When the cable strands are loosened she is' nasty hard to hold!
There is little time for sitting down, and little chance for gab,
For the bumper guards the crossing, and you'd best be keeping tab,
All of thirty "Let-Go's" every double trip—
It takes a bit of doing on the Powell Street Grip!

Throw her off at Pine Street, let her go at Post,
Watch her well at Sutter and at Geary when you coast!
Easy at the power house, have a care at Clay,
Sacramento, Washington, Jackson—all the way!
Drop your rope at Mason—never make a slip—
The lever keeps you busy, on the Powell Street Grip!

Foot-brake, wheel-brake, slot-brake, and gong,
'You'd better keep 'em busy or you'll soon be going wrong!
Rush her on the crossings, catch her on the rise,
Easy on the corners when the dust is in your eyes—
And the bell will always stop you if you hit her up clip;
You're apt to be kept busy on the Powell Street Grip!

North Beach to Eddy St., over old Nob Hill,
The grades are something giddy, and the curves are fit to kill!
An the way to Market Street, climbing up the slope,
Down upon the other side, 'hanging to the rope!
But the view of San Francisco, as you take the lurching dip!
There is plenty of excitement on the Powell Street Grip!

Oh, the lights are in the Mission, and the ships are on the Bay,
And Tamalpais' looming from the Gate across the way;
The Presidio flag is waving, and the hills are growing brown,
And the driving fog is harried from the ocean to the town!
How the pulleys slap and rattle! How the cables hum. and skip!
Oh, they sing a gallant chorus on the Powell Street Grip!

When the theatres are dosing and the crowds are on the way,
The conductor's punch is clicking and the dummy's light, and gay;
But the wait above the table, near the beach is dark and still—
Just the swashing of the surges on the shore above the Mill;
And the flash from Alcatraz is gleaming. 'cross the Channel rip
As the hush of midnight falls upon the Powell Street Grip!

ON THE COVER: Where are the crowds? This late-1940s view of Powell and Market Streets contrasts with today's tourist throngs. As schoolgirls cross the intersection, a Washington-Jackson cable car is being turned by a rookie gripman (at the front, pushing without a regulation jacket), the conductor, and the Market Street starter, who will assure No. 518 will leave on time. (Courtesy Emiliano Echeverria.)

IMAGES
of Rail

SAN FRANCISCO'S
POWELL STREET
CABLE CARS

Emiliano Echeverria and Walter Rice

ARCADIA
PUBLISHING

Copyright © 2005 by Emiliano Echeverria and Walter Rice
ISBN 978-1-5316-1660-1

Published by Arcadia Publishing
Charleston, South Carolina

Library of Congress Catalog Card Number: 2005929109

For all general information contact Arcadia Publishing at:
Telephone 843-853-2070
Fax 843-853-0044
E-mail sales@arcadiapublishing.com
For customer service and orders:
Toll-Free 1-888-313-2665

Visit us on the Internet at www.arcadiapublishing.com

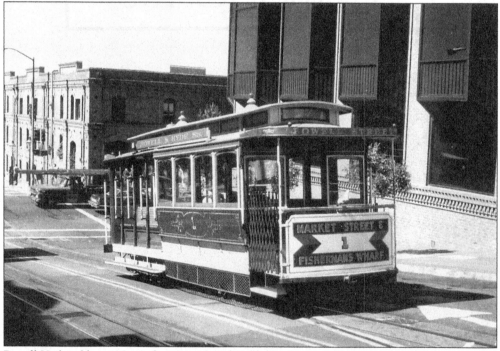

Powell-Hyde cable car No. 1, the "Centennial Cable Car," rests at Hyde and Beach Streets in 1974, before entering the turntable area. On December 1, 1997, a celebration was held at Victorian Park, at Hyde and Beach, to officially name the Powell-Hyde line turnaround the "Friedel Klussmann Memorial Turnaround." San Franciscans have honored the two most important persons in the history of its cable cars by naming public places for them. Hallidie Plaza, at Powell and Market Streets, is named for the man who invented the cable car, and the turnaround at Hyde and Beach is named for the woman who saved them. (Photograph by Walter Rice.)

CONTENTS

ACKNOWLEDGMENTS

The authors are indebted in writing this volume about arguably the world's most well known transit line, San Francisco's Powell Street cable car to many individuals. Some are known, and others are unknown—photographers whose names have long since been lost. There are too many to cite by name, such as the members of the "Cable Car Vigilantes" and the literally thousands of gripmen, conductors, trackwalkers, and many others who have made the Powell Street cable an operational reality since 1888.

A partial list of the collectors and photographers, many of whom are deceased, whose collections and photography have helped preserve the record of the Powell Street cable system, include David Banbury, Randolph Brant, William Farlow, James Gibson, Roy D. Graves, Tom Gray, Ray Long, Val Lupiz, A. J. Mc Donald, John Henry Mentz, Emmanuel R. Mohr, Vernon J. Sappers, Richard Schlaich, Lorin Silleman, Louis Slevin, Louis L. Stein, Chas. Smallwood, Isaiah West Taber, Al Thoman, Joe Thompson, Robert Townley, Paul Trimble, Wilbur Whittaker, Walt Vielbaum and the Bay Area Electric Railroaders Association, notably Bart Nadeau and the today's Market Street Railway. We recognize and apologize in advance if we inadvertently omitted a deserving name. Thank you all.

An instrumental person in the writing of this book is Robert Callwell of the San Francisco Municipal Railway. Certain sections are based on materials coauthored with Bob, and two of Bob's attributes deserve particular mention. First, Bob's love for San Francisco's transportation history and its accurate portrayal, and second his constant drive to improve the readability of this text. The authors share the first trait with Bob and aspire to his level for the second.

Our thanks go to Grant Ute and Joe Thompson for critiquing our initial draft and offering a series of comments that improved both the text's readability and accuracy; to Bob Townley for discovering and sharing the long-lost poem *Song of the Powell Street Grip* as well as W. D. Chamberlin's writings from before the earthquake and fire, covering from the United Railroads era to the 1944 end of the Market Street Railway and describing various forgotten Powell Street cable car projects; and to Mrs. Barbara Kahn Gardner, daughter of former MSRy president Samuel Kahn, for sharing her childhood memories of the Powell Street cable.

Lastly the authors would like to dedicate this book to the memory of the late Richard Schlaich, who served with distinction as member of the 1947 Citizens' Committee to Save the Cable Cars and later transit advocacy groups. We miss you, Dick.

Emiliano Echeverria
San Rafael, California

Walter Rice, Ph.D.
San Luis Obispo, California

INTRODUCTION

The world's most famous turntable is located at Powell and Market Streets in San Francisco. On March 28, 1888, the Ferries & Cliff House Railway Company (also called the Powell Street Railway) began cable car service on Powell Street from Market to Jackson. Cable cars with a secure future continue to this day on Powell Street.

Soon the company expanded its service. Eight days later, on April 5, the Ferries & Cliff House Railway Company (F&CH) opened its Powell-Mason line to Bay and Taylor. This route has never been changed, making it the world's oldest transit line using the same type of rolling stock and mode of power, whose routing (other than the 1941 move of the terminal about 75 yards south to take it out of an increasingly busy Bay Street) remains identical today with that of its inception. At the same time, the company opened a second Powell Street cable line: the Jackson Street via Powell line from Powell and Market to Central (Presidio) Avenue and California, serving the Western Addition outbound via Jackson and Central Avenue. Inbound cars returned on Central, Jackson, Steiner, Washington, and Powell to Market.

The Ferries & Cliff House Railway was San Francisco's seventh cable car company. Like its predecessors, the company was broadly built on the concept of Andrew Smith Hallidie's Clay Street Hill Railroad, the world's first street railway cable car that was successfully tested on August 2, 1873. A wire rope or cable is run at a constant speed in channels beneath the streets. A system of pulleys (grooved wheels) supports the cables from below, allowing them to move in the channels. At the end of a line, the cable is turned by a large pulley called a sheave (pronounced "shiv"), allowing the cable to return to the powerhouse and the cable cars to move in the opposite direction. This was an important feature of Hallidie's cable street railway design, which he adopted from his 1867 endless industrial ropeway system.

A cable car moves either by gravity or, primarily, by the cable car's grip extending through a slot between the rails that grabs hold of the cable like a giant pair of pliers and pulls the car along. The grip, weighing more than 300 pounds, lifts the cable from the pulleys, and it falls back onto the pulleys after the car passes by. To stop a cable car, the gripman disengages the grip from the cable and applies the brakes.

San Francisco also had counterbalance operations, the important Fillmore Hill line being the best remembered. The Fillmore Hill line opened from Broadway to Bay Street on August 10, 1895. It lasted until 1941, when it was replaced by motor buses, which were rerouted around the two-block section of Fillmore Hill. The 1893 Market Street Railway's Fillmore Hill counterbalance was designed and built under the supervision of Henry H. Lynch, then the Market Street Railway's superintendent of construction. Lynch had joined the Market after its 1893 acquisition of the F&CH. Lynch had been the F&CH's only superintendent. By the late 1930s, motor-bus and trolley or electric-bus technology had reached a point where buses could scale hills that had been previously the exclusive domain of the cable car. This change in technology was destined to affect the Powell Street cable operations.

The Powell Street cable cars have been operated by five companies. After the Ferries and Cliff House Railway came the Market Street Railway (1893–1902), the United Railroads of San

Francisco (1902–1921), the Market Street Railway (1921–1944), and the current operator the Municipal Railway of San Francisco (1944–present). Each of these companies contributed to the uniqueness of the Powell Street cable car operation.

The focus of this volume is cable cars on Powell Street. Traversing Powell Street from Market Street to Jackson, three lines qualify as true Powell Street cable car lines: Powell-Mason (1888–present); Powell-Jackson, also referred to as Washington-Jackson (1888–1956); and Powell-Hyde (1957–present). Three other cable car operations—the Sacramento-Jackson, also known as Ferries-Jackson (1888–1906); the Sacramento-Clay line (1914–1942); and today's California Street cable car (1957–present)—use Powell Street only for very short distance, and in the case of the latter two, only for non-revenue (no passengers carried) car-barn trips. Accordingly these lines are only incidental.

As a gesture to history and to be part of a large transportation industry exhibit at the 1893 Chicago World Columbian Exposition, on April 14, 1893, the F&CH sent out-of-service Clay Street Hill Railroad dummy (grip car) No. 8 and trailer No. 1 to Chicago. Shortly before F&CH began service, it purchased Hallidie's Clay Street Hill Railroad to achieve its corporate goal of serving the Ferry Building. It soon used the newly purchased franchises that came with the Clay Street company to expand its system beyond the Powell Street corridor. Dummy No. 8 is now on permanent exhibit at Municipal Railway's Washington-Mason cable carbarn and powerhouse.

Today's Powell Street cable cars are a product of many evolutionary design changes. Some cars have design aspects that are unique to that single car. Eight cars of the current Powell Street fleet of 28 cars are relatively new, built in the shops of the Municipal Railway. Although extensively rebuilt, four cars built by Mahoney Brothers date from 1887. Nevertheless, to the casual observer, the entire fleet, except for paint schemes, looks the same. The original cars were standardized by builder.

The initial car fleet consisted of three distinct groups of cars built between 1887 and 1894. With the exception of 1894 Market Street Railway Carter Brothers cars, all the cars were acquired by the Ferries & Cliff House Railway.

The first group of consisted of two subgroups—those credited with being built by the Mahoney Brothers and a subgroup of six cars built in the Washington-Mason shops of the F&CH. All these cars were characterized by Bombay roofs (a hump or "eyelid" at each end of the roof with a clerestory between), a four-window closed section (the size of a small horsecar), and no windows on the fronts. The sides had small arched windows with a wide letterboard separating the windows from the roofs. The Mahoney cars had a steel underframe, while F&CH car underframes were wooden.

Also part of the original 1888 cars credited to Mahoney Brothers was a single order of 10 totally open cars. They were basically built with a roof, seats, stanchions, and running gear. They saw service on all F&CH lines on fair-weather days. By 1893, these open cars received a bulkhead to divide the front from the rear and to provide extra needed support for the roof. This bulkhead was located in the same position as the bulkheads in the combination cars.

In late 1893 and early 1894, the Carter Brothers built 20 combination cars as a rush order to enable the Market Street Railway to serve the Midwinter Fair. Their bodies differed from the previous cars in that they had tall arched windows, no letterboard, and a single clerestory roof without the Bombay humps.

During the ownership of the 1893 Market Street Railway, the Powell Street fleet, other than being repainted and renumbered, remained unchanged. Because of a 1904 city ordinance that required cable cars, like electric streetcars, to have windows on their operating ends (as opposed to being open), the United Railroads (URR), owners of the Powell lines since 1902, made this required change. The fleet's appearance was drastically altered.

Only 27 cars the URR's F&CH Division fleet was spared from 1906 earthquake and fire. Twenty-four of these cars were ready for service. The other three were open cars that were brought to Washington-Mason where they were placed mainly in storage, only to be used occasionally. As Powell Street service requirements increased, the open cars were rebuilt into combination

cars. Another car, 533 (later 521 and still later 21), was similarly rebuilt after a serious accident. These rebuilds had straight passenger compartment sides below the windows (as opposed to curved sides) and large square windows. During the 1950s, these unique cars were rebuilt with the traditional curved sides.

Until 1951, this was the status of the Powell Street fleet. By the late 1940s, the fleet began to show its age. Although well maintained by their successive owners, there's only so much wear and tear wooden cars can take before they require major structural work. In March 1951, starting with car 501 (later I-28), Powell Street cable cars went to Muni's Elkton Shops for reframing and other repairs. Often this resulted in an almost entirely new car. Only the roof, seats, bulkheads, and hardware were retained.

This reconstruction program resulted in each car being rebuilt to somewhat different designs. On the Mahoney type cars, the short arched windows were replaced by square windows that were not as large as the square windows put on the former open cars during their rebuilding. After the scrapping of car 514 in 1963, all of the original Mahoney configuration cars were gone. Later, when Muni decided to construct entirely new cable cars, two of the replacements for former Mahoney-type cars II-514 (now 14) and 21 had single clerestory roofs, typical of the Carter Brothers cars.

The Carter Brothers cars fared a better. There are a few Carter Brothers cars, still in service, that have retained their original body design, but most of the Carters have received square windows. Muni probably saw such standardization as a desirable cost-saving procedure.

This resulted in a different appearance for almost each car, and unfortunately, erroneous Muni folklore began to circulate, as a justification for this differentiation that said that "the cars were hand made, therefore individual." The cars were, as originally built, in fact standardized, per group.

Arched windows in 1973 began to return on the rebuilds, with different dimensions than on the original cars. Since the early 1980s, Muni has developed a new standard design that is being used on all rebuilds and new cars. Beginning with the second car No. 4, placed in service in 1994, Muni began to replace cars that had Bombay roofs with new Bombay roofs cars. Eventually there may two standard groups of Powell cable cars: cars with Bombay roofs and those without. Muni's policy of painting certain cars in the paint scheme representative of former Powell Street cable car companies will still differentiate Powell cable cars in the public's mind.

Today the Powell Street cable lines (and its California Street cousin) represent the world's sole surviving example of the type of street railway that was the first to provide a successful universal alternative to animal power (i.e., horse or mule cars). There has never been a published comprehensive Powell Street cable history. Our goal is to correct this deficiency.

So grab a handle and come aboard a running board for a story from the mists of the distant and not so distant past of the ups and downs of the Powell Street cable car lines.

One

THE FERRIES AND
CLIFF HOUSE ERA

(1887–1892)

San Francisco of the mid-1880s had spread out beyond the South-of-Market Street and North Beach districts into the Mission District, and-west into the Western Addition to the cemeteries (today's Presidio Avenue), halfway to the Pacific Ocean. Portsmouth Square was no longer the center of commerce. Market Street was now the city's most important thoroughfare. The hill areas—Nob Hill, Russian Hill, and Pacific Heights—were reachable via slow, circuitous horsecar routes (e.g., Pacific Avenue) and cable car lines (e.g., California Street) that failed to provide direct service to the new center of economic activity, the fast developing retail area near Union Square.

The idea of cable cars on Powell Street began in the mid-1880s, when Gustav Sutro, owner of the Omnibus Railroad & Cable Company, projected a line of steam dummies and cable cars, called the Park & Cliff House Railway, to run from downtown to the resort area near the Cliff House being developed by his cousin, mining entrepreneur Adolph Sutro. Gustav sold his interest in the scheme, before it moved beyond the planning stages, to W. J. Adams, a sawmill owner and lumber dealer who was actively promoting a north-south cable route, the Powell Street Railway, up Nob Hill. Adams combined the two projects into the Ferries & Cliff House Railway (F&CH), although he continued to refer to the lines as the Powell Street Railway.

Construction on the company's initial two cable lines, Powell-Mason and Powell-Jackson, lasted most of 1887 and into 1888. Work was completed in the middle of February 1888, and testing began immediately. The Powell-Mason line served several important and populous areas of the city that had been largely ignored by the other cable lines. As noted above, cable car service on Powell Street from Market to Jackson Street began on March 28, 1888. Full service on the Powell-Mason line began on April 5, 1888, linking the fashionable shopping area surrounding Union Square, the elegant residential neighborhoods of Nob Hill, and the largely Italian North Beach district. The line's northern terminal at the then–bay front at Bay and Taylor Streets was convenient to Fisherman's Wharf.

An east-west Powell-Jackson line also opened on April 5, 1888. At Central Avenue and California, connections were made with the company's steam lines, which went into service the following July.

Newspapers projected that the Powell-Jackson cable would open up an "extensive and desirable" region that would furnish home sites for "thousands of artisans, merchants and clerks." At the outset, F&CH had 22 combination cable cars (cars with an open front section followed by a closed compartment, like today's Powell Street cable cars) and 10 open cars, all obtained from Mahoney (sometimes spelled "Mahony") Brothers.

Economics argued against a cable car extension west of Central Avenue, since population density was too sparse and traffic too subject to seasonal variations to justify the large initial investment required of a cable car system. Management favored steam operation, since it could commence for a fraction of the investment cost of cable technology. Accordingly, the F&CH built two connecting three-foot-gauge steam lines—one to Golden Gate Park, the other to Land's End near the Cliff House. It is important to note that these connectors generated a significant amount of traffic for the company's Powell Street cable cars, which otherwise would have been lost to competitors.

In September 1887, F&CH principal owner W. J. Adams purchased from Andrew Hallidie the world's first cable car line, the Clay Street Hill Railroad, for $200,000, considered by local observers to be a high price. With this purchase, the F&CH secured an uncontested route east from Powell Street to the Ferry Building, the most important terminal in the entire western United States. This purchase allowed the F&CH in September 19, 1888, to open a branch of the Jackson Street line—the Ferries-Jackson line also known as Sacramento-Jackson. The former Clay Street Hill line that had run from Kearny Street was now reduced to a shuttle from Powell Street, its new eastern terminal, to Van Ness Avenue.

Around 1890, the F&CH paid its conductors and gripmen 22¢ per hour; a workday was between 11 and 11½ hours, making a daily platform wage of about $2.40. Conductors and gripmen were paid daily, while other employees were paid monthly. Trackmen and shopmen received $60.00, oilers and sweepers $65.00, firemen to fire the steam boilers $70.00, and engineers $100.00.

On July 30, 1891, plans for the new Sacramento-Clay line were announced. When opened that fall, the new line ran from the Ferries to Walnut and Sacramento Streets using Clay Street outbound and Sacramento inbound east of Larkin. The Clay Street Shuttle was absorbed into this new line. To equip the new line, 10 more cars were ordered from Mahoney, and 6 additional cars of identical design were built in the F&CH's Washington-Mason shop. This brought the fleet strength to its peak under F&CH ownership—48 combination cars and 10 open cars. An additional carbarn on Sacramento near Walnut was opened. This facility was destined to play a critical role for the Powell Street cable car lines in the post–1906 earthquake and fire era.

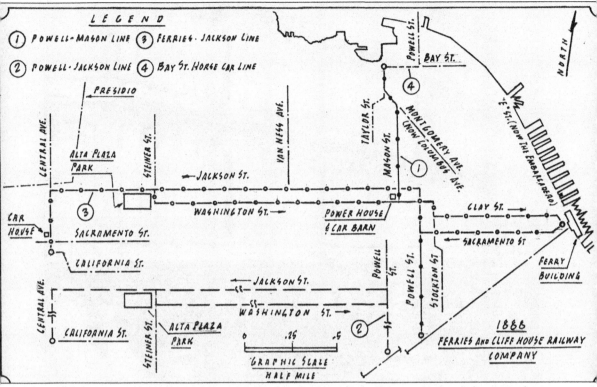

This map shows the lines Ferries & Cliff House Railway (Powell Street Railway) during its first year, 1888. The Ferries and Jackson line (designated as "3") from Central Avenue to the Ferries opened in September of that year. (Map by Don Holmgren.)

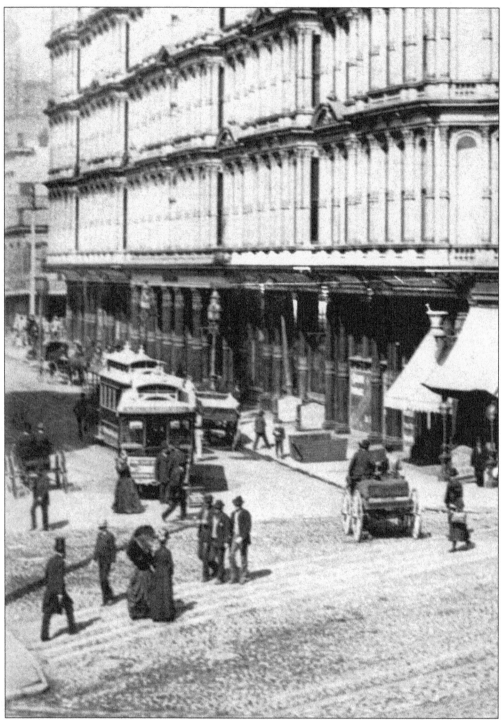

In 1892, at the turntable at Powell and Market, a Mahoney Brothers–type Powell Street car boards passengers at the stand while another completes its turn on the turntable. Prior to the 1906 earthquake, only Mahoney Brothers–type cars ran on the Powell Street lines. (Courtesy Marilyn Blaisdell.)

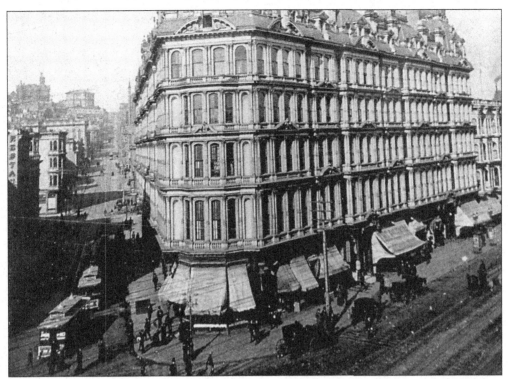

From the beginning of service, the turntable at Powell and Market Streets has been marked by prominent buildings. When this photograph was taken in 1889, "Lucky" Baldwin's hotel was considered second only to the revered Palace Hotel. The Baldwin Hotel stood from 1877 until 1898 on the site of today's Flood Building. (Courtesy Emiliano Echeverria.)

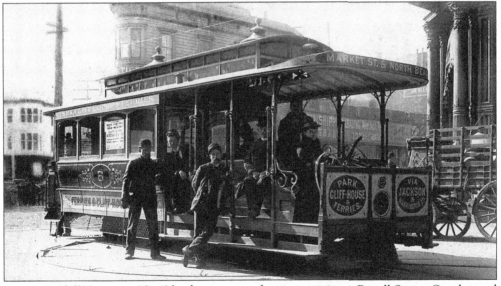

Ferries & Cliff House car No. 6 loads passengers for its next trip up Powell Street. Cars lettered for the "Ferries & Cliff House Railway" rarely operated on Powell Street, as those cars usually were assigned to the Ferries-Jackson line. Powell Street cars were typically signed "Powell Street Railway." Where are the crowds? (Courtesy Richard Schlaich.)

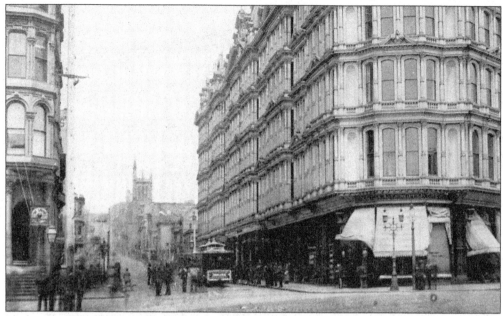

Looking up Powell Street from Market in 1892, a single car awaits passengers at the "stand." Only Mahoney-type cars were seen on Powell Street before the 1906 earthquake. The Carter Brothers–built cars were not acquired until early 1894 and started running on Powell Street in 1907. (Courtesy Emiliano Echeverria.)

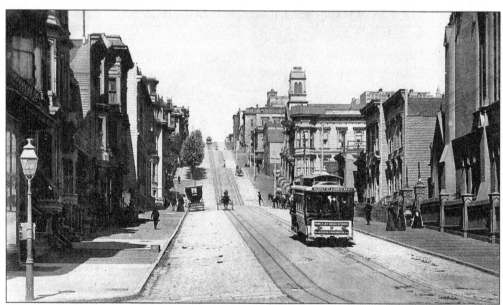

The building of the Powell Street Railway was indeed a major victory for the residents of North Beach. A new connection between North Beach and the new downtown shopping area centered at Union Square was a service highly anticipated. In this 1890 photograph, a Powell Street car is seen at Post. (Courtesy BAERA Archives 24361, Sappers Collection.)

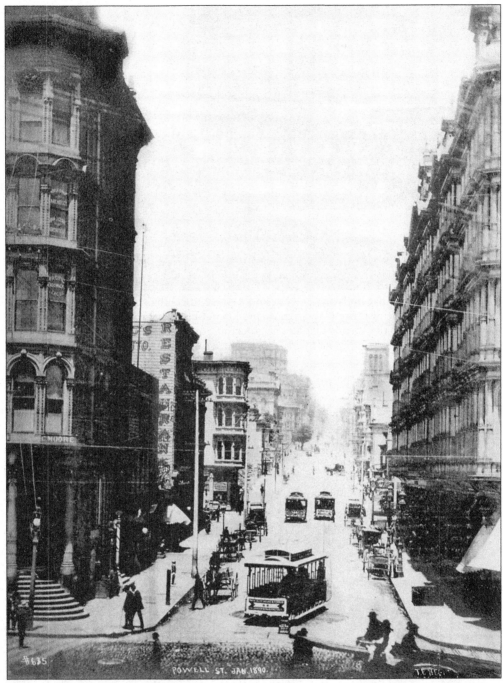

On fine days, open cars provided some of the Powell Street service. Needless to say, open cars never were very popular in often-foggy San Francisco. Only 10 open cars were built for the Powell Street Railway. Careful inspection reveals that, as built, the open cars lacked supporting bulkheads. (Courtesy Richard Schlaich.)

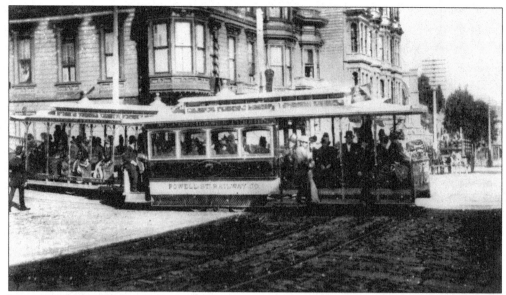

It is a nice 1890 day that finds an open car and a standard combination passing at Powell and Sutter Streets. In the distance is the Synagogue Emanu-El, site of today's 450 Sutter Medical Building. Beyond are the Vienna Gardens at Stockton Street. (Courtesy Richard Schlaich.)

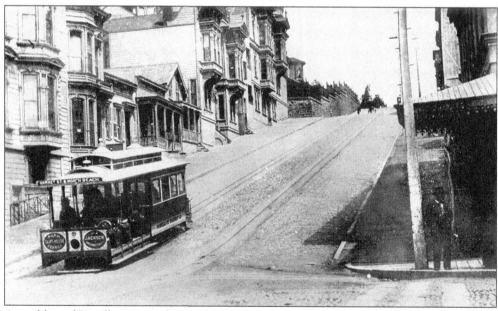

A southbound Powell car, No. 9, has reached Bush Street on its way downtown. Maybe some society ladies are going to a matinee at the Baldwin, next to the turntable at Market Street. A horsecar line owned by the Sutter Street Railway crossed Powell here. (Courtesy Randolph Brant.)

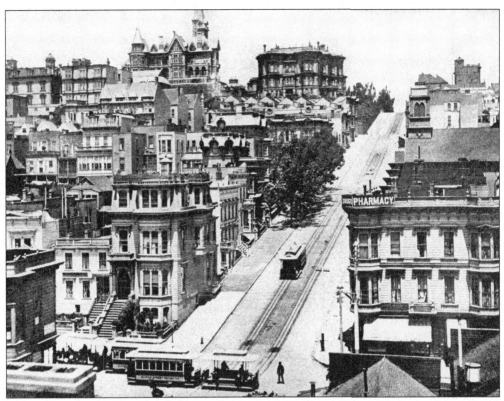

A yellow Mason line car descends Powell from Bush to Sutter Street, while two Sutter Street Railway cable trains meet at the crossing with Powell. The Leland Stanford and castellated Mark Hopkins mansions (upper left) dominate the scene, in more ways than one. Let's hope that the Sutter line trains clear the Powell Street tracks in time! (Courtesy Richard Schlaich.)

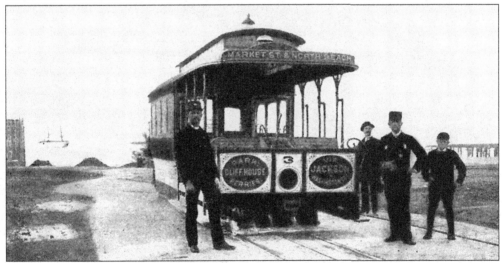

When the Powell Street Railway's Powell-Mason line was built, the turntable at Bay and Taylor Streets was on the waterfront. During the 1890s, the bay was filled in north of Bay Street. A ship and a portion of the seawall, then under construction, can be seen in the background. (Courtesy Charles Smallwood.)

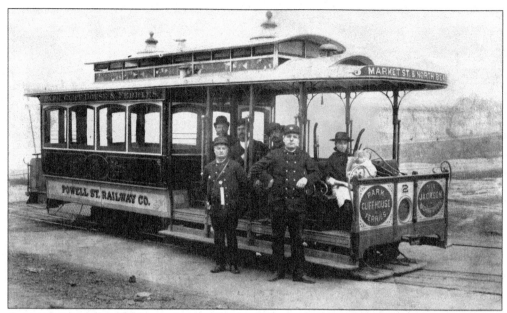

An unidentifed Powell-Mason crew poses proudly with their car that has been pushed off the Bay and Taylor turntable, 1889. The young woman with her baby is likely anticipating a day of downtown shopping. From this location, in 1892, a short F&CH-owned horsecar line operated to the east along Bay Street. (Courtesy Richard Schlaich.)

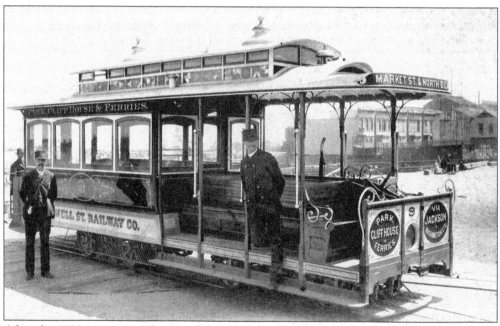

After the 1888 opening of the Powell-Mason line, industries sprang up in the area along the bayfront. At this time, Fisherman's Wharf was not here. It was located much closer to the Ferry Building at the foot of Union Street nearer to Telegraph Hill. (Courtesy Randolph Brant.)

A turntable was built in 1891 for outbound Ferries-Jackson cars to negotiate the intersection of Jackson and Mason Streets. Until the earthquake of 1906, it was used to convey westbound cars of that line from Mason Street's northbound track (to right) to Jackson Street (to left). A curve of any type at this location was impossible, due to terrain. The turntable was removed in 1912. (John Mentz/URR photograph; courtesy Richard Schlaich.)

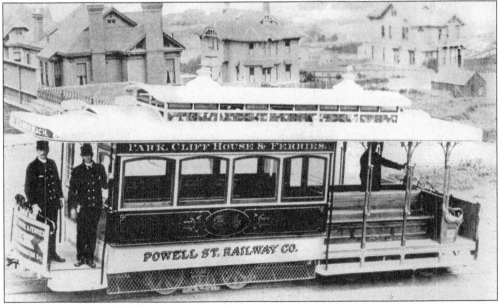

In the 1890s, Pacific Heights became a magnet for the mansions of San Francisco's new elite, largely as a result of the building of the two Jackson Street lines—from the Ferry and Powell and Market Streets. About a third of the lots had been developed when this 1891 photograph was taken. (Courtesy Richard Schlaich.)

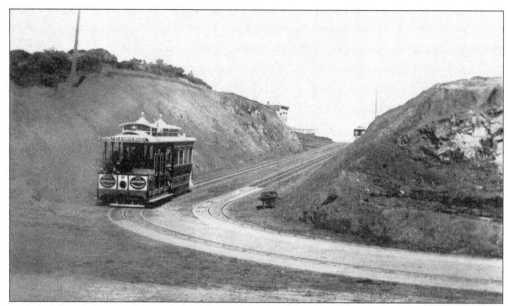

In 1888, the area surrounding Jackson Street and Central (now Presidio) Avenue was a wide open space. Soon after, cable cars from Powell Street, and later the Ferry, urbanized the landscape of both the Western Addition and Pacific Heights. Today fine houses line this now urbane area of San Francisco. (Courtesy Bancroft Library, Roy Graves Collection.)

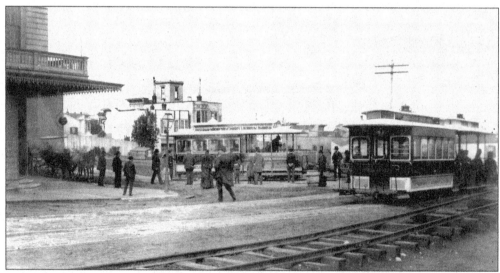

The original western end of the Jackson Street line was located at Central (now Presidio) Avenue and California. Here a Jackson Street cable car is on its turntable, while in the foreround a cable train of the California Street Cable Railroad lays over at its terminal. Passengers transferred here to connecting steam trains to Golden Gate Park and the Cliff House. (Courtesy Charles Smallwood.)

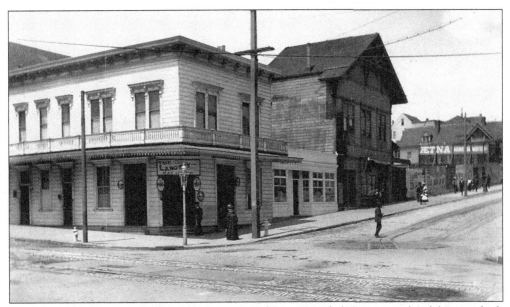

This rare 1905 view shows the turntable at Central (now Presidio) Avenue and California, which served both Jackson Street cable lines—Powell-Jackson and Ferries-Jackson. The building at left, after being a saloon for many years, became Dr. Henna's Dog and Cat Hospital. It was razed in 1932 to make way for the original Jewish community center that stood at this location until 2002, when it was replaced by a new facility. (John Mentz/URR photograph; courtesy Randolph Brant.)

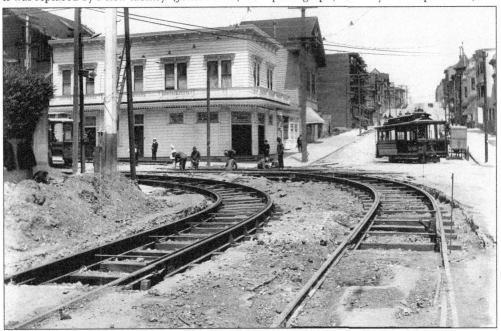

The year is 1905, and the two Jackson Street cable lines will only have another year to serve Central (Presidio) Avenue and California. From here, cable car passengers could travel to either Powell and Market Streets or to the Ferries at East Street. Car 459, on the Powell-Jackson line, has just arrived and is about to be turned for its return downtown journey to Market Street. (John Mentz photograph; courtesy BAERA Archives 24374.)

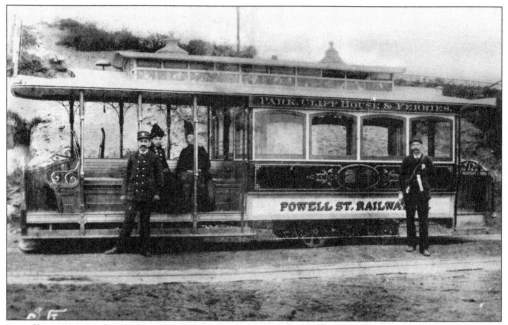

Powell car No. 26 shows the original configuration of these cars—without a front end, with two horizontal front seats separated by an opening to allow the gripman to throw the grip forward to release the cable. This early photograph also illustrates the barren topography of outer Jackson Street. Where are the paying customers? (Courtesy Rudy Brandt.)

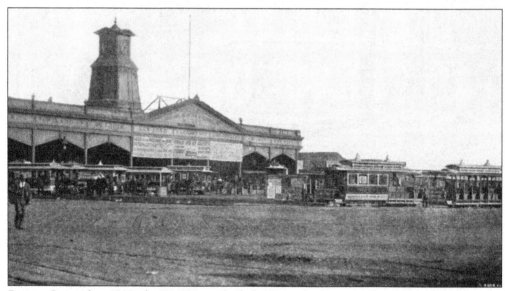

During September 1888, the F&CH reached the Ferry, living up to the corporate title of the railway. The previous July, the railway had reached the Cliff House via its connecting Central Avenue narrow-gauge steam line. This 1890 photograph shows both a traditional combination car and an open car at the Ferry. (Courtesy Richard Schlaich.)

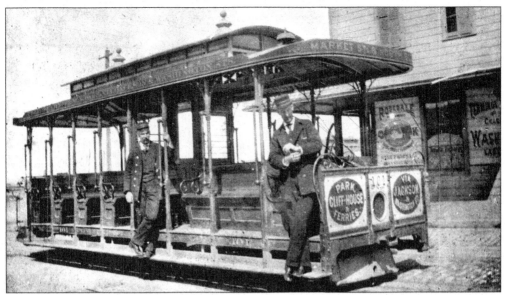

Open car No. 101 is at an unidentified location in 1889 with crew J. A. Lowry and Bill Keller proudly posing. All 10 Powell Street open cars were built in 1887. Only three open cars survived the 1906 earthquake and fire. Eventually they were all rebuilt as standard combination cars. Until their recent retirement and replacement with new Muni built cable cars, these former open cars had the distinction of being the oldest Powell cars. (Courtesy Richard Schlaich.)

The fireman has just finished putting water into the tank for another trip from Central Avenue to the Cliff House. After taking water, the engine will couple its cars, and then is ready for another trip to the beach. By the time this photograph was taken in 1905, the fate of the line was already sealed; conversion to an electric streetcar line is about to occur. (John Mentz/URR photograph; courtesy Richard Schlaich.)

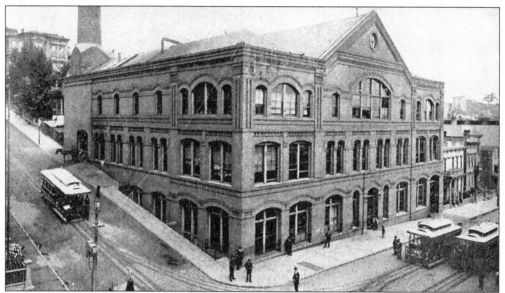

In this view of the Washington-Mason car and powerhouse, we see an eastbound Jackson line car on Washington Street, a southbound Mason line car ready to drop the cable to take the curve into Washington Street and an outbound Ferries-Jackson Street line car is northbound on Mason Street en route to Jackson Street. The top floor of Washington-Mason held all car building and maintenance shops for the railway. Six cars were built here. (Courtesy *Street Railway Journal*.)

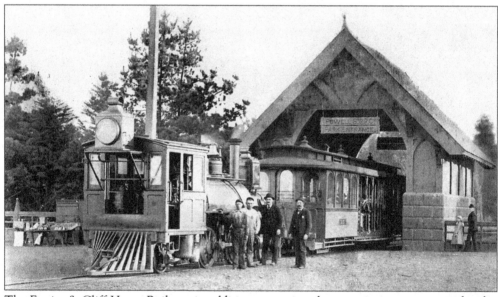

The Ferries & Cliff House Railway, in addition to serving the areas in its corporate title, also served Golden Gate Park. Here we see a steam train inside the 1890 built Park Depot, located at Seventh Avenue and "D" (now Fulton) Street. In existence over 115 years, the depot still proudly displays its "Powell St. R.R. Park Entrance" sign. (Courtesy Randolph Brant.)

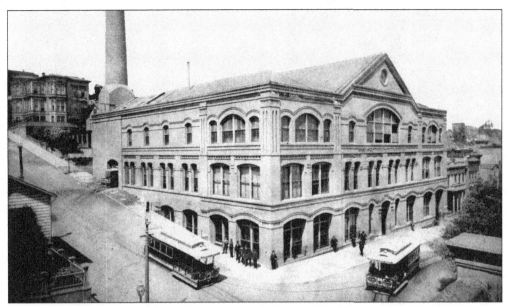

This is how the power and car house of the Ferries & Cliff House Railway appeared when the railway opened in 1888. The gripman of the Jackson Street car has already dropped his rope, and waits while an inbound Mason Street car takes the curve from Mason to Washington. The bottom floor was (and still is) given over to cable machinery, while the upper two floors held the cars at night. (Courtesy Richard Schlaich.)

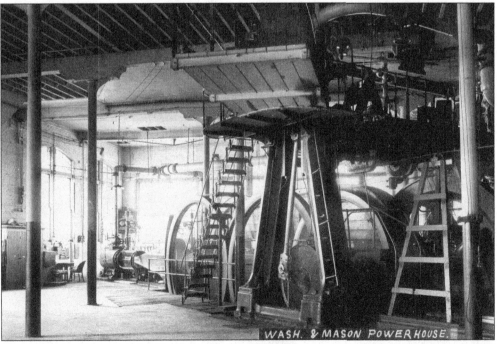

The cable machinery winders inside of Washington-Mason powerhouse, in April 1905, looked well maintained, even after 16 years of continuous use. Today, although the machinery is in the third Washington-Mason powerhouse, the scene still looks much the same. (John Mentz/URR photograph; courtesy Richard Schlaich.)

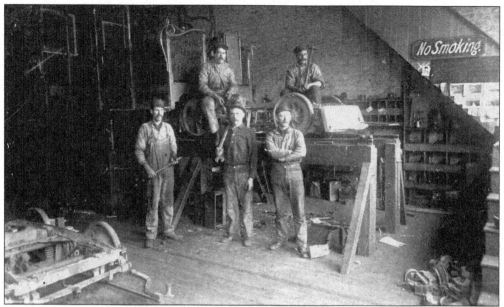

On the third floor of the Washington-Mason car house were the carpenter and car building shops. All repairs and heavy maintenance work was done here. In fact, six cars were built here in 1891. A group of craftsmen gather for a *c.* 1900 group portrait. (Courtesy Richard Schlaich.)

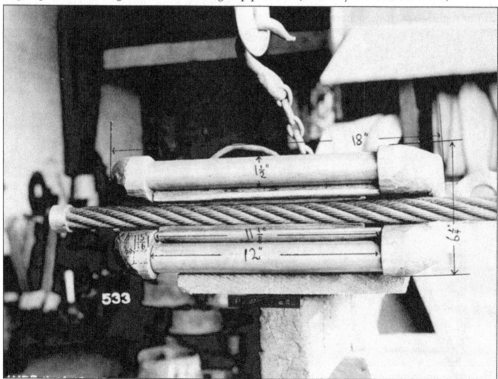

This 1905 view shows the bottom of the Eppelsheimer bottom grip, the type of grip used continuously since 1887 on the Powell Street system. Note the details of construction of the grip. (John Mentz/URR photograph; courtesy Charles Smallwood.)

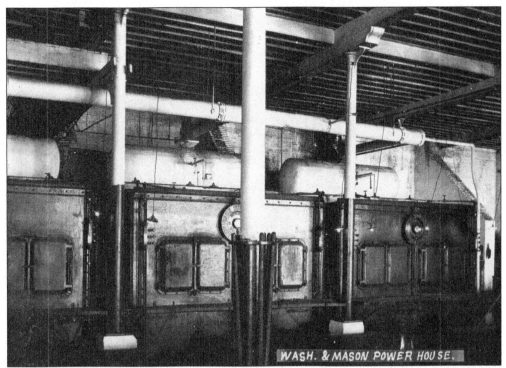

The Washington-Mason powerhouse was the system's only powerhouse, except for the extension from Sacramento and Walnut Streets to Golden Gate Park (1894–1901). These elephant-type boilers provided motive power from 1888 until 1912 and remained on standby until 1926. (Courtesy Richard Schlaich.)

Adjoining the California Street steam car house and sharing a common rear wall was the Sacramento Street cable car house. This building, outside the 1906 fire zone, held 24 of the 27 500-series cable cars that would in 1907 restore Powell Street cable car service. (John Mentz/URR photograph; courtesy Randolph Brant.)

Nestled behind the Queen Anne corner building was the tiny Central Avenue carbarn, which housed a few cable cars and horses that were used to move the powerless cable cars in various carbarns. Three future Powell Street cable cars were stored here and survived the 1906 great fire. The structure, built in 1887, was designed to store over night a limited number of Jackson Street cable cars, thus avoiding trips to and from Washington-Mason. (John Mentz/URR photograph; courtesy Randolph Brant.)

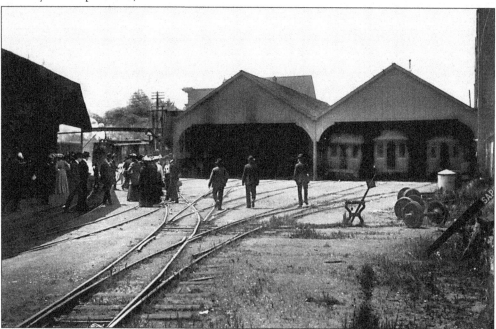

Here is a very rare photograph showing the car house for the steam cars of the two Ferries & Cliff House steam lines. At left, a train is returning to this compact yard via the California Street track. The boarding platform is at the far left in this photograph. (John Mentz/URR photograph.)

Two

Southern Pacific and the "Baltimore Syndicate"

(1892–1906)

The Ferries & Cliff House Railway incurred a debt of $1.9 million during its construction. This and other heavy-bonded indebtedness forced the sale of the F&CH on October 14, 1893, to the Pacific Development Company, a subsidiary of the Southern Pacific Railroad. This sale was part of a larger consolidation under the banner of the Market Street Railway.

The year 1893 was full of financial depression for San Francisco and the country. To turn the depressed economy around, M. H. de Young, publisher of the *San Francisco Chronicle*, decided that San Francisco was in need of its own world's fair. De Young immediately began to rally public enthusiasm for such a fair. Soon he convinced the Golden Gate Park Commission to allow "Concert Valley" near the Inner Richmond to be the site of the exposition. Only five months after the ground-breaking, the California Midwinter International Exposition opened on January 27, 1894.

On February 19, 1894, the Market Street Railway opened an extension of its Sacramento-Clay to serve directly the exposition. On Sundays and holidays starting February 26, 1894, the two Jackson Street cable lines, Powell-Jackson and Ferries-Jackson, were also extended directly to the fair using the new extension. Connecting curves were installed at the intersection of Sacramento Street and Central Avenue. Outbound cars using a right-hand drift curve coasted from Central Avenue to Sacramento Street. Once on Sacramento Street, it was easy for the gripmen to pick up the cable, since it was high in the slot at that point because the line was at a base of an ascending grade. This practice is used today by outbound Powell-Hyde cable cars at Jackson and Mason Streets. To avoid the upgrade on Central Avenue, instead of turning left from Sacramento Street to Central Avenue, inbound cars instead used a right-hand drift curve from Sacramento Street to Central Avenue. The cars coasted the block to California Street, where they used the turntable to reverse direction and head downtown. Weekday service on the Jackson Street lines continued, as before, directly to the turntable at California and Central Avenue.

The only San Francisco street railway to receive mail contracts was the Market Street Railway. The Railway Post Office (RPO) car that was assigned to the former F&CH lines was car "B," a rebuild from an out-of-service former Omnibus cable car that was shortened by four feet to allow it to fit the

Powell Street system turntables. This car carried postal clerks who performed their normal duties en route. Powell Street cable cars in regular service revenue were also used in closed-pouch service. These cars carried a sign in their front window that read "US MAIL." RPO service was discontinued in September 1905, while the closed-pouch services ended with the earthquake of April 18, 1906.

By 1901, other than the Powell-Mason line, the former F&CH cable car lines were on borrowed time as intact entities. In the Nob Hill and Russian Hill areas, the streets were too steep for electric operations; however, the streets west of Van Ness Avenue were another story. In the Western Addition, cable car curtailments could be made due to easier grades on streets whose width would accommodate streetcars. By 1901, Market Street Railway was drawing up plans to abandon all of their cable lines west of Fillmore Street and replace them with new electric trolley lines. The conversions would have to be limited in scope, since the city still prohibited electric streetcars on Market Street. There was apparently no way to get the city to relent on this restriction.

The final route adjustment of the former F&CH cable lines under the Market Street Railway management did not directly involve the Powell lines. As of January 2, 1902, Sacramento cable west of Walnut Street was replaced by an electric line. Many combination cable cars, thus, became surplus and were fortuitously placed into storage in the Sacramento Street barn.

On March 20, 1902, the Market Street Railway including its former F&CH properties, merged with other properties to create the United Railroads of San Francisco (URR). Service on all former F&CH cable lines continued unchanged until April 18, 1906—the date of the great earthquake and fire. Powell-Mason cars and Sacramento-Clay ran daily from about 6:00 a.m. until 1:00 a.m. the following morning. However, the Ferries-Jackson line ran from 6:00 a.m. to only 6:30 p.m. The first Powell-Jackson cable car left California and Central Avenue at 10:05 a.m.; the last car left at 12:22 a.m. Between 10:05 a.m. and 6:30 p.m., Ferries-Jackson and Powell-Jackson cars provided alternate service on the Jackson Street corridor.

At the time of the URR takeover, Powell cars were painted in line colors assigned in 1894 by the Market Street Railway: yellow for Powell-Mason, red for the Sacramento-Clay, and green for both Jackson Street lines. In 1905, all cars received the uniform URR paint scheme: maroon and cream sides, maroon front and rear, and a grey roof.

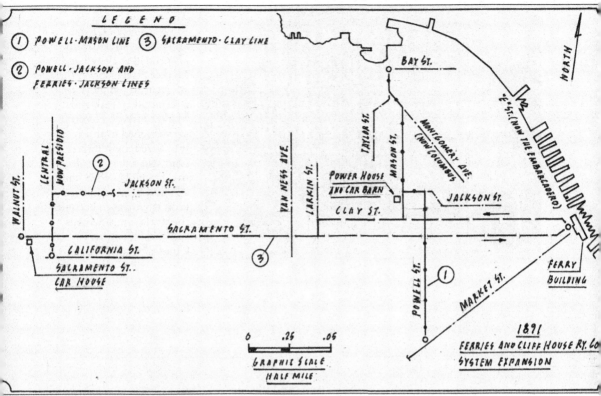

By 1891 the Ferries & Cliff House had expanded. Added was the Sacramento-Clay line ("3"), and the Ferries & Jackson line was now routed off of Powell Street to Mason Street outbound and Stockton Street inbound (not shown). (Map by Don Holmgren.)

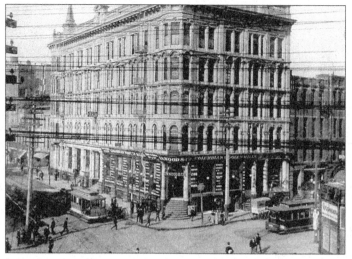

The Market Street Railway's Ferries, Park, and Ocean streetcar line also ended at Powell and Market Streets. Soon the streetcar would move to a terminal at Turk and Market Streets. Electric cars assigned to this line were rebuilt former Omnibus cable cars. In this December 1898 image, a Powell Street cable car is on what was to become the world's most famous turntable. (Courtesy Charles Smallwood.)

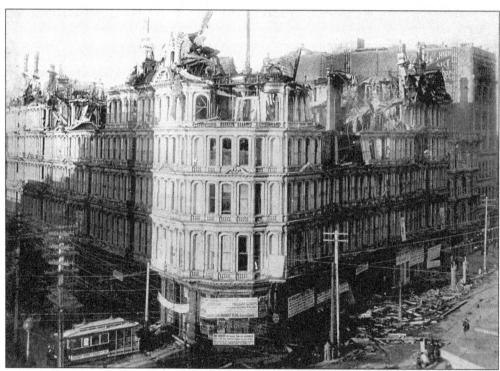

A tragic precursor to the 1906 disaster was the 1898 burning of the Baldwin Hotel at the foot of Powell Street that claimed many lives. Lucky Baldwin's luck ran out. Powell Street cars resumed service while the embers were still warm. The debris was eventually cleared away, and after a few years, the still-standing Flood Building was erected in its place. (Courtesy Marilyn Blaisdell.)

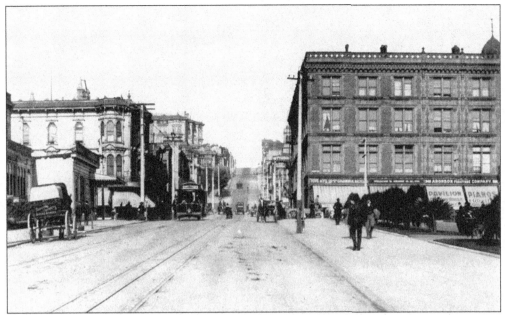

By 1895, the church formerly at the corner of Powell and Post Streets was replaced by an office building. Union Square is to the right, while a southbound car approaches Post. A few years later, the St Francis Hotel was built on the block to the left, replacing the Calvary Presbyterian Church. (Courtesy Bancroft Library, Roy Graves Collection.)

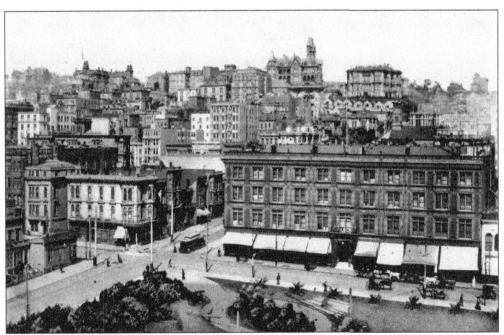

This postcard view taken from the unfinished Newman-Levinson Building (later I. Magnin's store, and today part of Macy's) shows the intersection of Post and Powell in 1905. In the background are the Stanford and Hopkins mansions, long since given over to semipublic uses as parts of schools. (Britton & Rey postcard courtesy Emiliano Echeverria.)

A close-up of a Powell-Mason car at the Bay and Taylor turntable, around 1896, shows how these cars looked during the Market Street Railway era. The car was yellow, with red lettering and a red roof. (Courtesy Don Holmgren.)

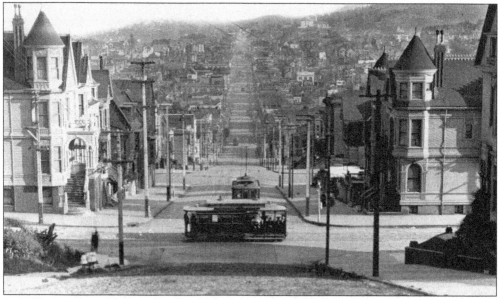

In 1905, a westbound Jackson Street cable car crosses Divisadero Street en route to California and Central (Presidio) Avenue. After the 1906 earthquake, cable car trackage on Jackson Street west of Steiner was removed, being replaced by the Sutter-Jackson electric streetcar line. (Courtesy Peter Linenthal.)

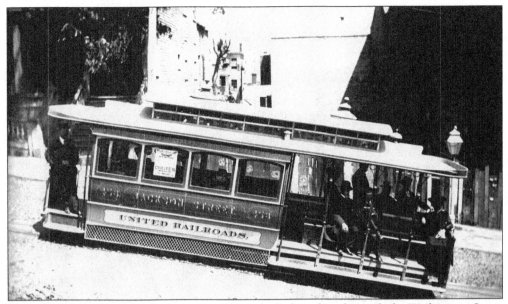

Illustrating transition in car lettering, car 468 on the Jackson line descends the Washington Street grade opposite the Washington-Mason car house. The car still has its Market Street Railway colors, but the name of the ownership now reads "United Railroads." (John Mentz/URR photograph; courtesy Richard Schlaich.)

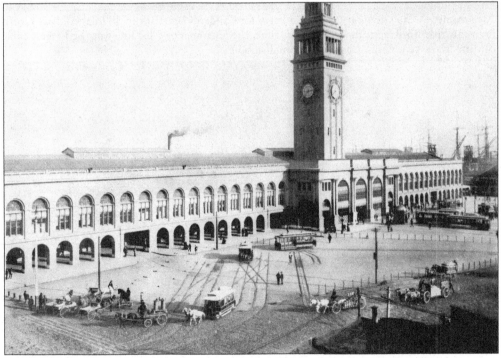

By 1902, the new Ferry building is almost completed. The world-famous façade is already greeting commuters and visitors. A Carter Brothers Sacramento-Clay line car is being turned to face Clay Street for another trip to Golden Gate Park. Note the short stub at the turntable used for spotting the mail car "B." (Courtesy Richard Schlaich.)

A Sacramento-Clay line car leaves the Ferry for Golden Gate Park in 1898 as soldiers return from the Spanish-American War. At this time, the Sacramento-Clay line was the longest cable car line in the city. (Courtesy Charles Smallwood.)

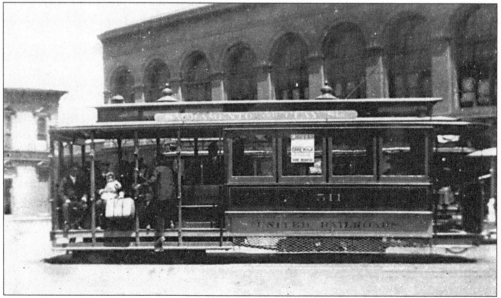

In its new URR colors, Carter Brothers–built car No. 511 is at the Ferry in late 1905 on the Sacramento-Clay line. Within two years, this car had a new permanent assignment on Powell Street. No. 511, today's No. 11, although much rebuilt, is still in service on Powell Street. (Robert McFarland photograph; courtesy Richard Schlaich.)

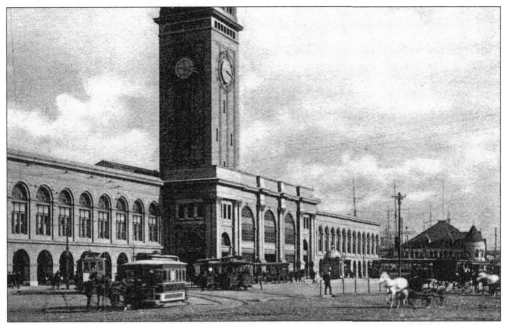

In 1905, a Carter Brothers car on the Sacramento-Clay line and a Mahoney Brothers car on the Ferries-Jackson line await passengers at the stand by the new Union Ferry Depot. Both cars will end their respective western journeys a block apart. (Albertype print courtesy Emiliano Echeverria.)

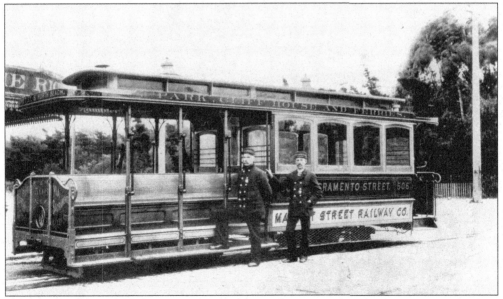

The 1894 Midwinter Fair has arrived, and the new Carter Brothers cars are ready to bring the crowds. Carter Brothers car No. 506 is at the corner of Sixth Avenue and "D" (Fulton) Street. The roof of this car is today in service as part of Powell Street car No. 1, which entered service in 1973. (Courtesy Louis L. Stein Jr.)

Rail Post Office (RPO) cable car "B" was assigned to the Sacramento Street line. Between 1896 and 1902, it ran to Golden Gate Park. Thereafter its route was shortened to Sacramento and Walnut Streets. RPO service was withdrawn in September 1905, and car "B" was destroyed in the fire of 1906. (Courtesy Randolph Brant.)

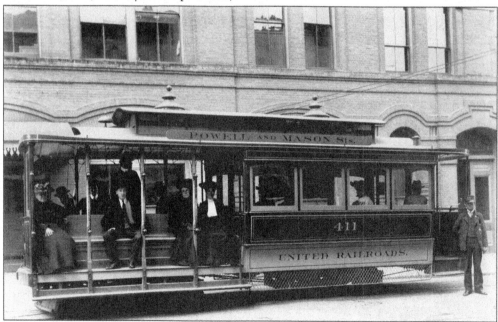

By April 1905, the former Ferries & Cliff House cable car fleet began to appear in its new URR colors—a body featuring Tuscan red side panels with cream rocker panels below the rub rails. The company name "United Railroads" was emblazoned on the rocker panels. The window sashes were also red, while the roof was grey. Because of the events of April 1906, not all of the former F&CH cars received this paint scheme. (John Mentz/URR photograph; courtesy Richard Schlaich.)

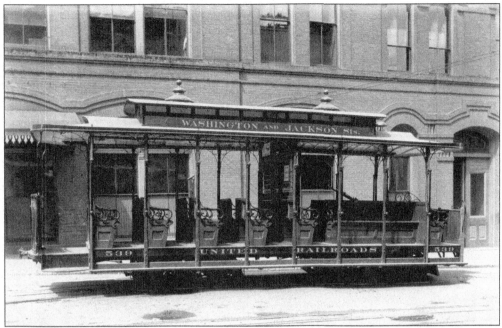

Also in 1905, all 10 of the 1887 open cars were renumbered into the URR numbering system and repainted in a blue color scheme. They received mid-car bulkheads for strengthening. This April 1905 photograph was taken in front of the Washington-Mason car house. (John Mentz/URR photograph; courtesy Richard Schlaich.)

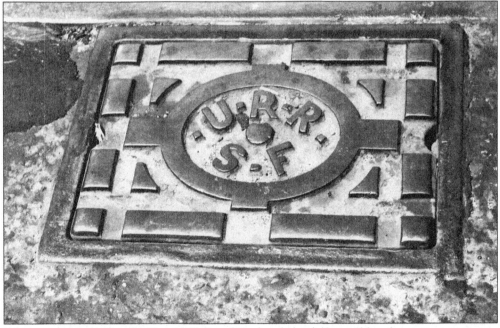

Like most street railroads, United Railroads ordered manholes and hatch covers appropriate for its various structures in the public streets. This plate was located at Bay and Taylor and is typical of the plates found throughout the system. Some of these URR plates lasted until 1982. (Photograph by Ray Long.)

It is about 10 a.m. on the dreadful of morning of April 18, 1906. The Washington-Mason car house has been heavily damaged by the earthquake. The smokestack has broken and crushed the car that would have been the first car of the day, No. 455. Washington Street is covered with debris. Soon 455 will be moved to allow undamaged cars inside to be "evacuated" to Bay and Taylor Streets in the vain hope that the fire would not reach them. But it did. (Mentz photograph; courtesy BAERA Archives 24373.)

Three

EARTHQUAKE AND FIRE

A SHORTENED SYSTEM

(1906–1921)

At precisely six seconds after 5:12 a.m. on April 18, 1906, San Francisco changed forever. One witness likened the great earthquake to a terrier shaking a rat. Sixty hours later, after the fires had ceased raging, much of the northeast section of the city lay in ruins, including the former Ferries & Cliff House, now United Railroads–owned Washington-Mason powerhouse and car barn.

A total of 92 cable cars were assigned to former Ferries & Cliff House lines prior to that fateful April morning. Of this total, all 65 cars assigned to Washington-Mason were destroyed. By noon, it became clear that Washington-Mason may burn, as the whole downtown was by this time either burning or imminently threatened. A decision was made to evacuate as many cars out of the barn as possible and shove them to North Beach, out of harm's way. Throughout the afternoon, using gravity, and horses when needed, cars stored on Washington-Mason's ground floor were moved by employees to Bay and Taylor Streets, well out of the fire-zone, or so it was thought.

On the night of the April 20, the last day of the fire, all the cars "rescued" at Bay and Taylor were lost, reduced to ashes and hardware. That night, the massive walls of the Washington-Mason came crashing down in flames, destroying all of the burnable contents. Only the stub of the smokestack was left standing (and still is standing).

Twenty-seven cars at other locations were saved. Twenty-four combination cars assigned to either Sacramento-Clay, Ferries (Sacramento)-Jackson, or stored out-of-service were saved by being in the Sacramento Street carbarn located on the south side of Sacramento Street between Central Avenue and Walnut that was outside of the fire zone. Three open cars, which later would be rebuilt into combination cars, were also spared, as they were located in a small barn around the corner on the west side of Central Avenue just north of Sacramento. These 27 survivors were used to operate the two Powell Street lines when service was restored.

Washington-Mason powerhouse's coal-fired steam engines were connected to shafts that transmitted the energy to large gears, which turned the winding drums that powered the cables. In 1901, a conversion was made to oil. Oil-powered steam operation continued after the earthquake

and fire in the smaller "temporary" replacement Washington-Mason facility. The 185-foot-tall smokestack was shortened to approximately 60 feet, due to a major crack in the upper part of the stack. The switch to oil, with its much lighter smoke, meant proper venting could occur with a much smaller smokestack. (The only part of today's third Washington-Mason facility that is original to 1887 is the shortened smokestack.)

Prior to this holocaust, the United Railroads had wished to convert as much of its vast cable car system to electric streetcar, as topography would permit. The URR's attraction to the electric car is easy to understand. Streetcars had greater speed and capacity, allowing for more passengers per hour and greater revenues, and streetcar lines had significantly lower construction and operating costs than cable cars. However, many powerful San Franciscans were adamantly opposed to trolley cars and their overhead wires. "Wires are ugly and a menace." "Pipes will get corroded." The opponents of the streetcar were successful in prohibiting overhead wires on the major thoroughfares of Market, Geary, and Sutter Streets, as well as some lesser streets such as Pacific Avenue and Jackson.

Because of the post-earthquake emergency, an ordinance allowing the conversion of the URR's cable car lines to streetcar service passed. When the URR restored service on many cable car lines, it was with electric cars. The former F&CH system was partially affected by this conversion. The heavily-traveled Ferries (Sacramento)-Jackson was abandoned without replacement. On January 30, 1907, United Railroads restored cable car service on Powell Street from Market to Jackson only. The full Powell-Mason line was restored from Market Street to Bay and Taylor on March 1.

On that same date, the Powell-Jackson line opened, now shortened to Steiner Street and renamed "Washington-Jackson." West of Steiner Street electric streetcars replaced the cable car service. To allow for the shortening of the Powell-Jackson cable the URR constructed a new cable sheave wheel pit at Jackson and Steiner Streets to reverse the cable and built a new three-rail, dual-gauge, cable-electric outbound track on Jackson Street from Fillmore to Steiner.

A new Jackson Street pull-in gate that allowed Washington-Jackson and northbound Powell cars to coast directly into upper Washington-Mason car storage level was placed into service. Southbound Powell cars from Bay and Taylor and Sacramento-Clay cars continued to enter the carbarn as they had prior to the earthquake. They entered from the barn's Mason Street front and were conveyed via elevator to the car storage level. All cars left the storage area by coasting directly onto Washington Street.

Steam could not hold out indefinitely against the economies and reliability of electricity. In 1912, a 600-horsepower General Electric motor replaced the traditional vertical steam engines to power Washington-Mason's cable lines.

In 1918, extensive changes were made in the foundations of the Washington-Mason powerhouse's winding machinery, including a new concrete foundation and general realignment of the large pinion shaft and bearings. A year later, a new 14-foot, 15,000-pound, cast-iron winding wheel was installed at the powerhouse to replace one that broke.

These changes were required because the URR's post-earthquake management felt that continued Powell cable car operation would only be for the short run. Therefore, construction standards in the post-earthquake environment were minimal. Two of the three Powell Street open cars were rebuilt into combination cars, one in 1913 and the other in 1915. Another two cars underwent a major rebuilding after major accidents.

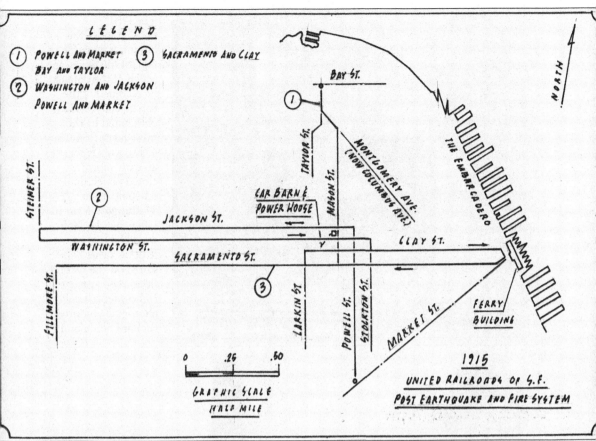

① POWELL AND MARKET
 BAY AND TAYLOR
② WASHINGTON AND JACKSON
 POWELL AND MARKET
③ SACRAMENTO AND CLAY

BAY ST.

①

STEINER ST.

②

JACKSON ST.

WASHINGTON ST.

SACRAMENTO ST.

③

CAR BARN &
POWER HOUSE

TAYLOR ST.

MASON ST.

MONTGOMERY AVE.
(NOW COLUMBUS AVE.)

THE EMBARCADERO

NORTH

CLAY ST.

FILLMORE ST.

LARKIN ST.

POWELL ST.

STOCKTON ST.

MARKET ST.

FERRY
BUILDING

0 .25 .50

GRAPHIC SCALE
HALF MILE

1915

UNITED RAILROADS OF S.F.

POST EARTHQUAKE AND FIRE SYSTEM

After 1906, the former Ferries & Cliff House cable car system endured reductions in its track mileage. During the post-earthquake period, the United Railroads eliminated all cable car trackage west of Steiner Street, replacing cable car service with streetcars. The Sacramento-Clay line was closed by the Market Street Railway in February 1942. (Map by Don Holmgren.)

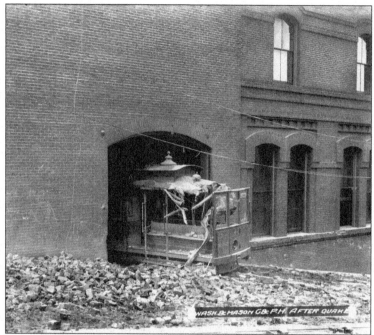

The URR photographer was busy that eventful April 1906 morning. Much of the damage he recorded of the earthquake was later obliterated by the subsequent fires. Car 455 was ready for an early morning, closed-pouch mail schedule from Washington-Mason. Later that day, 455 would be moved to allow other cars stored on the second floor to be evacuated. (John Mentz/URR photograph; courtesy Richard Schlaich.)

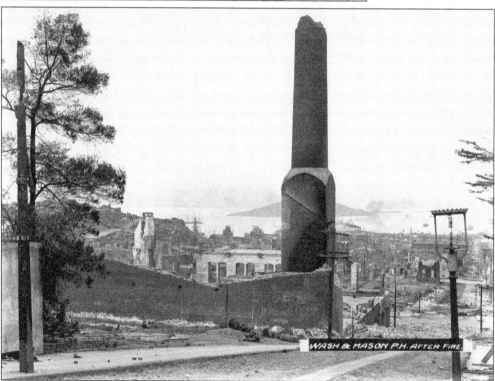

A few days after the fire had abated, the photographer returned to the scene to record the utter destruction of the Washington-Mason car and powerhouse. The chimney, the winding machinery, the boilers and bricks were what URR was left with to rebuild. (John Mentz/URR photograph; courtesy Richard Schlaich.)

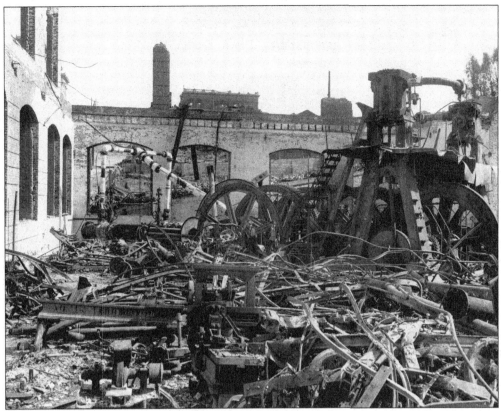

Compare this photograph with one from the previous page, and imagine the task that lay ahead, clearing the tangle of twisted metal, melted cable and bricks that were everywhere. The winding wheels are nearly buried in debris. Within a year, however, the mess was cleared and the winders were back in operation. (John Mentz/URR photograph; courtesy Richard Schlaich.)

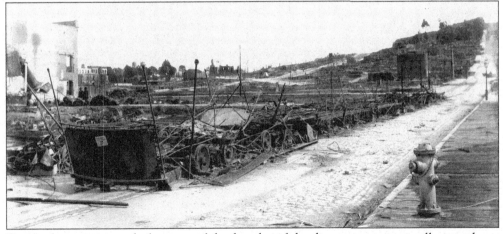

During the morning and afternoon of the first day of the disaster, crews manually moved cars from Washington-Mason's second floor onto the street, where, with the aid of gravity and horses, they were sent to North Beach, at Bay and Taylor Streets. There both tracks were filled. All was to no avail, however, as all of these cars burned on the last day of the fire, as shown in this May 1906 photograph. (John Mentz/URR photograph; courtesy Richard Schlaich.)

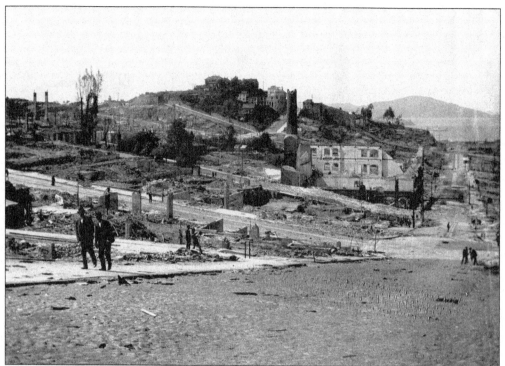

By mid-1906, most of the streets in the vicinity of the Washington-Mason site had been cleared of debris. No operating cable cars are in evidence; that would be months in the future. The work of cleaning the mess of the cable machinery is about to begin. (Courtesy Richard Schlaich.)

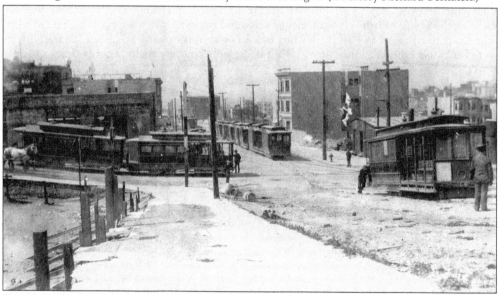

When this early 1907 photograph was taken, service had only been restored from Powell and Market Streets to the site of the Washington-Mason car house. This had occurred on January 30, 1907. Service on the other parts of the Powell Street system had to wait for completion of track work. Meanwhile, extra cars are stored on the street. (John Mentz/URR photograph; courtesy Richard Schlaich.)

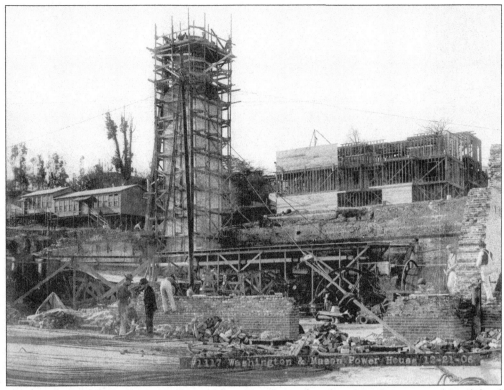

The smokestack is being reconfigured to a new lower height of 60 feet, since the oil-fired boilers required less draft than the prior coal-fired boilers. It is just before Christmas 1906, and service is a little over a month away. The repaired cable machinery is visible. On the hill in the distance are the portable classrooms of Washington Grammar School. Such classrooms have graced San Francisco's schoolyards for over a century. (John Mentz/URR photograph; courtesy Paul Trimble.)

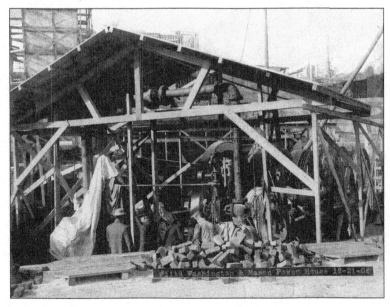

The work of cleaning, oiling, and readying the cable-winding machinery is nearly completed. Winter is here, and the mechanisms are under protective cover. (John Mentz/URR Photo, Paul Trimble collection.)

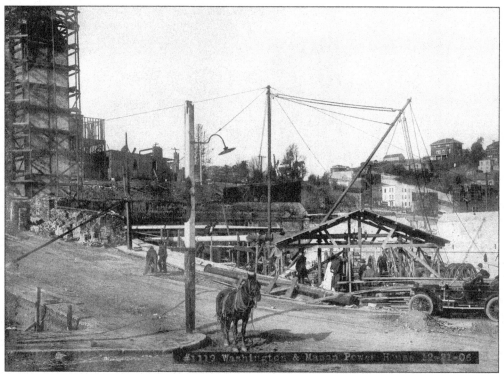

By the end of December 1906, the rebuilt powerhouse is substantially complete, although the machinery is still out in the open. Track work needs to be finished so that new cables can be installed. (John Mentz/URR photograph; courtesy Paul Trimble.)

A postcard issued in mid-1907 shows a half-built Washington & Mason car and powerhouse, with a car running on Mason Street near Vallejo. By this time, only the Sacramento-Clay line was awaiting its reopening. (Charles Weidner postcard courtesy Emiliano Echeverria.)

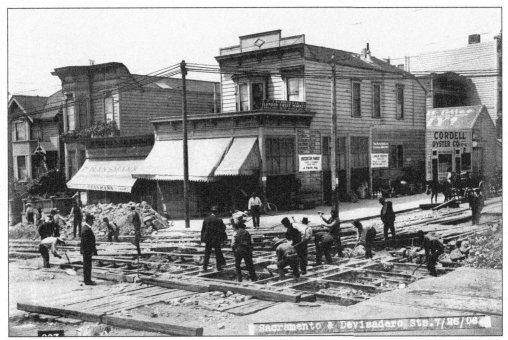

All the cable car trackage west of Steiner Street of the former Ferries & Cliff House Railway was eliminated after the 1906 earthquake and fire. At Divisadero Street and Jackson, the cable special work is being removed from the crossing, and a new crossing only for streetcars will be installed. (John Mentz/URR photograph; courtesy Paul Trimble.)

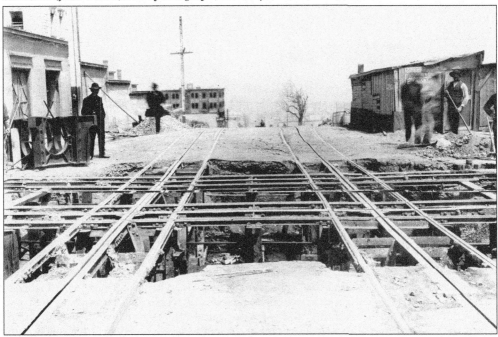

Even after the cable cars in 1907 returned to the streets, work went on rebuilding the system, despite the fact cars ran every few minutes. In this view looking north, a new cable car crossing is being installed at Powell and California Streets in mid-April, 1907. (Courtesy Walter Rice.)

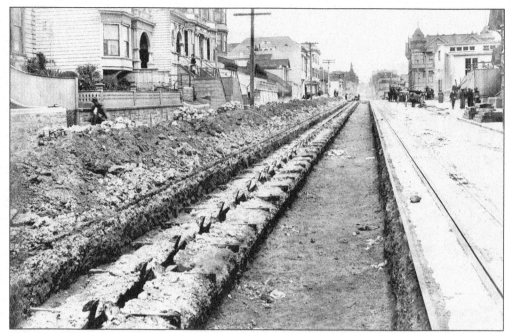

Removing cable car track was not an easy job. It was backbreaking, noisy, and dirty. Pictured here in July 1906, on Sacramento Street west of Fillmore Street, is a denuded conduit ready for dismantling and removal. (John Mentz/URR photograph; courtesy Paul Trimble.)

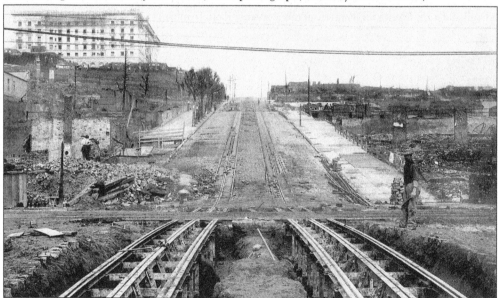

By mid-December 1906, Sutter Street cable car trackage the entire length of Sutter had been replaced by electric railway tracks. It was now time to install a new track crossing at Powell and Sutter. A crossing had not been installed when the Sutter Street was rebuilt as an electric line during the post-earthquake period. Sutter Street streetcar service began during that July, months before cable cars could return to Powell Street. By December, it was apparent that Powell cable cars would soon be running and, therefore, construction of crossing was a necessity. (John Mentz/ URR photograph; courtesy Paul Trimble.)

A new sight in 1907 on Powell Street was the appearance of the Carter Brothers–built cars, which had before the earthquake only run on the Sacramento-Clay line. Previously only Mahoney-type cars were seen on Powell Street. The Carter cars would now constitute the majority of the Powell Street fleet. (Courtesy Emiliano Echeverria.)

A Powell car is southbound between Bush and Sutter, in a scene which illustrates a small piece of the magnitude of the 1906 disaster. A Montgomery Street streetcar passes eastbound on Post Street at the bottom of this photograph from around 1907. Temple Emanu-El is being rebuilt to the right. (Courtesy Emiliano Echeverria.)

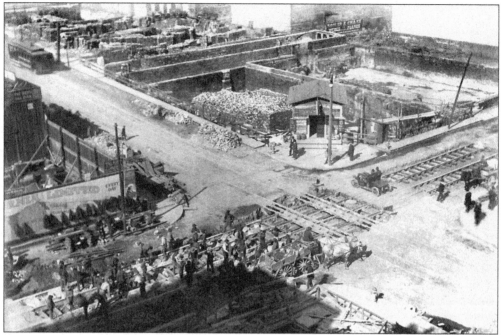

A year after the earthquake, Powell Street had still only begun to be rebuilt. Track work is occurring throughout the city on both cable car and streetcar trackage. A northbound Powell Carter Brothers car approaches O'Farrell Street. (John Mentz/URR photograph; courtesy Paul Trimble.)

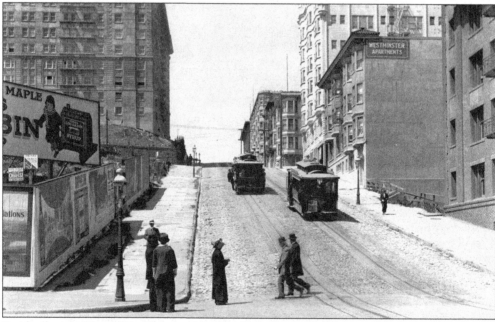

Besides the rebuilding of San Francisco's financial, retail, manufacturing, and commercial sections of town, residential districts required significant reconstruction efforts. This August 1914 photograph of two Powell cable cars passing just south of Pine Street illustrates the new requirement by the city that new apartment buildings be either reinforced concrete or steel frame. (John Mentz/URR photograph; courtesy Randolph Brant.)

February 1916 shows the Powell Street lines running through the major downtown shopping district, a feature that remains today. Southbound car 525 (car 25, today) stops at Geary, while a northbound car approaches Post. The world famous St. Francis Hotel is to the left. (John Mentz/URR photograph.)

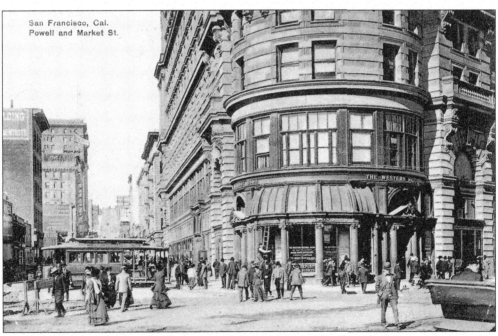

This late-1907 postcard shows a Washington-Jackson Mahoney Brothers–built car on the turntable, still in its 1905 red-and-cream paint scheme. The reconstruction of the shopping district on Powell Street is underway. (Pacific NoveltyCompany postcard; courtesy Emiliano Echeverria.)

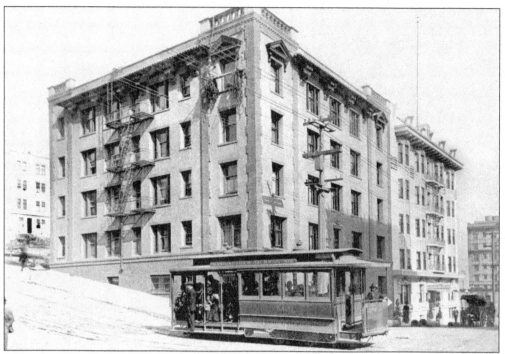

Around 1909, car 513 pauses at Bush Street before making its climb to Pine, where the gripman will await the green light from the signal tower operator to proceed and cross California Street. Car 513 ran until 1988, when it was wrecked. (Courtesy Marilyn Blaisdell.)

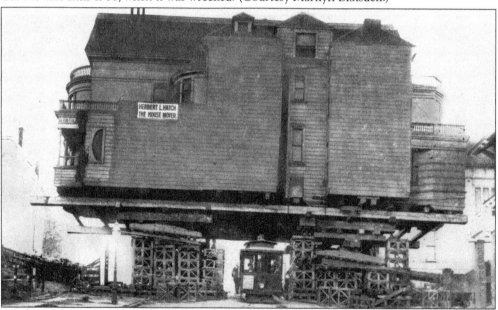

Alma Spreckels was very clear: houses were to be moved, not demolished, to clear the land for her and husband Adolph's new showcase mansion, which still stands at Octavia and Washington Streets. In 2005, it is owned by author Danielle Steele. Nevertheless, URR had a schedule to maintain. The solution was to lift the house over the cable car line. Washington-Jackson car 516, accordingly, is running under the house in this 1914 photograph. (Courtesy Richard Schlaich.)

A Sacramento-Clay car lies over on East Street (today's Embarcadero) in front of the Ferry. This view looks to Commercial Street, an alley with significant connections with the city's early days. Commercial Street was most important as the "Long Wharf," the city's principal door to commerce in the early 1850s. (John Mentz/URR photograph.)

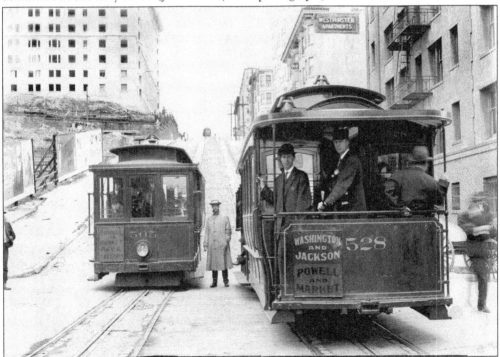

This April 1914 "meet" on Powell Street at Bush between Mahoney- and Carter-type cars was a sight unimaginable before the fire. The conductor on the rear platform with his hand on the rear brake. Then and now, Powell Street conductors are responsible on hills for setting the rear track brake. (John Mentz/URR photograph; courtesy Richard Schlaich.)

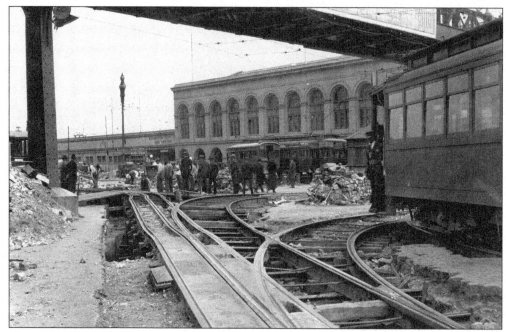

When electric streetcar requirements caused the Ferry loop to be expanded, the loop infringed upon the Sacramento-Clay cable car trackage. Since altering the location of cable car tracks was both expensive and difficult, the URR's solution was a shared gauntlet on Market Street for a few dozen yards. Both electric and cable cars would share one rail. (John Mentz/URR photograph.)

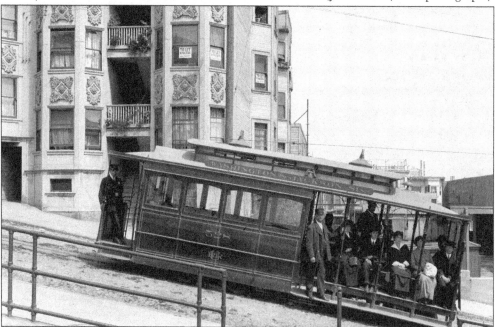

Car 528 descends the Washington Street hill next to the Washington-Mason car house in 1914. It is interesting to compare this scene with the same location in 1905 in the previous chapter. This car was renumbered 514 in 1929 and ran until 1961. It was scrapped in 1963, the last totally original Mahoney-style body to run. (John Mentz/URR photograph; courtesy Richard Schlaich.)

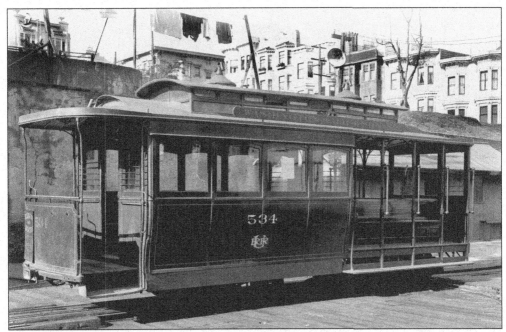

By 1915, all of the cars assigned to Washington-Mason were uniformly painted in the URR colors of a dark green body, red roof and window sashes, with striping and numbers in gold. Green, in one form or another, would remain the basic body color of the Powell Street cable cars until 1982. (John Mentz/URR photograph; courtesy Richard Schlaich.)

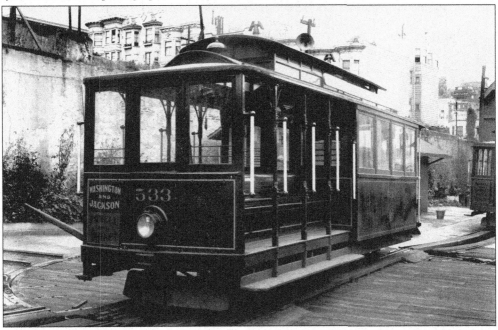

In 1918, car 533 was involved in a major accident that nearly destroyed it. Pictured here September 18, 1918, it was rebuilt with straight sides and large, square windows. In 1929, 533 was renumbered to 521. Rebuilt again in 1954, it received curved side panels from Muni's Elkton Shops. Renumbered 21 in 1974, it ran until 1982. (John Mentz/URR photograph; courtesy Richard Schlaich.)

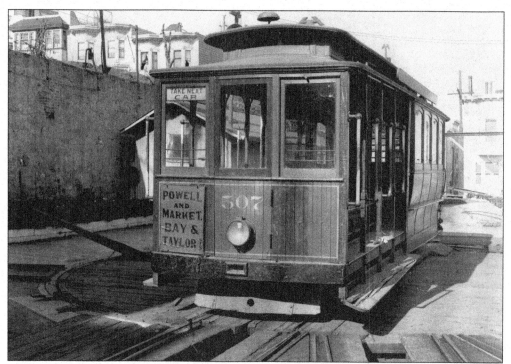

At the Washington-Mason outside yard, car 507 models the representative appearance of the front end of Powell cars, near the end of the URR era in 1919. The look is very utilitarian when compared to the elaborate paint and striping jobs that characterized prior schemes. (John Mentz/ URR photograph; courtesy Richard Schlaich.)

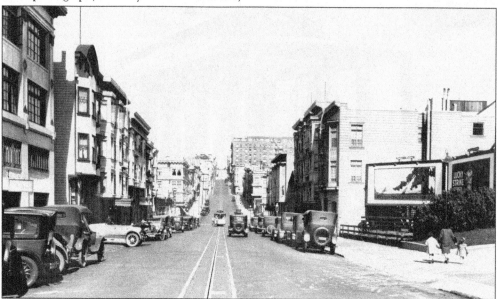

During the early 1920s, the automobile had made its presence on the residential streets of San Francisco commonplace, as this view of Washington Street looking east of Polk shows. How many former cable car riders are now more concerned with the price of gas than cable car fares? (Courtesy Emiliano Echeverria.)

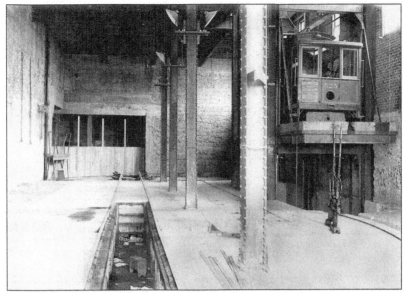

In both the original structure of 1888 and its 1907 successor, an elevator was utilized to facilitate car movements throughout the Washington-Mason car barn. The elevator was necessary because of limited space relative to the number cars stored. In 1888, there was no large storage yard available. No such elevator exists in the current (1984) building, partially because the number of cars quartered today is approximately two-thirds that of the pre-earthquake era. (John Mentz/URR photograph; courtesy Richard Schlaich.)

The original 1887, three-story Washington-Mason cable carbarn and powerhouse was a victim of the April 1906 earthquake and fire. The United Railroads then built a smaller "temporary" facility on the site of the destroyed remnants. In 1918, the URR was forced to make extensive changes to the foundations of the Washington-Mason powerhouse's winding machinery, including a new concrete foundation and general realignment of the large pinion shaft and bearings. Pictured here in 1921 is Washington-Mason—the heart of the Powell Street cable car system. (Courtesy Richard Schlaich.)

UNITED RAILROADS OF SAN FRANCISCO
DAILY TIME CARD

Department ...

Date .. *19*

DESCRIPTION OF WORK	HOURS
TOTAL	

Name...

Rate.................... *Per*.................... *No.*

CORRECT ...

FOREMAN

Powell Street gripmen, conductors, and all Washington-Mason employees daily filed, under United Railroads management and predecessor and successor ownerships, a time card as a method of tracking their pay. The URR was infamous for its strong anti-union policy and labor unrest. Strikes, and the threats of strikes, characterized labor-management relations. During both 1907 and 1917, the Powell cables were shut down because of violent strikes. (Courtesy Emiliano Echeverria.)

Four

New Ownership, the Cable Car Lady, and the Mayor

(1921–1947)

On April 1, 1921, the Market Street Railway took over the operating properties of the United Railroads. When Henry Huntington, the owner of the Market Street Railway, sold the railway in 1902 to the "Baltimore Syndicate" (which soon organized the United Railroads of San Francisco), the *Call* reported that the purchase price of $26 million in cash was the most "colossal cash purchase every made in this country." The equivalent in 2005 is $2.234 billon. In addition, the Syndicate assumed all of the Market's outstanding bonded indebtedness for it and all its underlying properties.

The URR was doomed by this impossible burden, combined with the extraordinary costs associated with the earthquake and fire of 1906, electrification of cable car lines, two long and bitter strikes (in 1907 and 1917), large-scale misuse of company funds by company president Patrick Calhoun, and competition from the Municipal Railway and jitneys. Between 1902 and 1921, the Market Street Railway continued as a financial corporation, holding much of the URR's debt. That financial corporation eventually passed from Southern Pacific control to a group of local banks. When the URR defaulted, its major creditor, the Market Street Railway, reemerged as the operating company.

The sole accomplishment of consequence of the initial management of the reborn Market Street Railway, with respect to the Powell Street cable, was that the third and last Powell Street open car was rebuilt during 1923 into a combination car. Two years later, the Market Street Railway was sold to the Standard Gas & Power Company, who hired the Byllesby Engineering & Management Corporation to run the company. To head the Market Street Railway, Byllesby selected in November 1925 Samuel Kahn, who had successfully headed other Byllesby properties, notably at Stockton, California. Kahn would head the Market Street Railway until two years after its 1944 sale to the City and County of San Francisco. Samuel Kahn himself became the principal owner in the late 1930s.

Barbara Kahn Gardner, Samuel Kahn's eldest daughter, has childhood memories from the mid-1920s of the family sitting at the dinner table in suburban Hillsborough when the phone rang.

"The cable car system has a major break down. Cars need to be towed to Washington-Mason." Samuel Kahn would then authorize the rental of teams of horses from livery stables to tow the stranded cars back to the car house. Horses were soon replaced by company trucks.

A 1927 study by the city revealed that the Powell Street cable car lines had annual 1926 profits of $41,009 for the Powell-Mason line, $49,400 for Washington-Jackson, and $11,090 for Sacramento-Clay. Also in 1926, all steam operation of the Powell cable ended when a second complete electrical drive was installed. During the 14 years since 1912, it had been necessary only occasionally to "fire up" the steam apparatus. However, since it took between five and six hours to get sufficient steam up to power the reciprocating engines, major service delays were encountered.

In the 1930s, cable car ridership dropped significantly because of the Great Depression. Samuel Kahn looked for ways to reduce costs. By the late 1930s, the technologies of both motor and trolley buses had improved so much that steep hills could be mastered by these rubber-tired vehicles. Cable car costs when compared to motor and trolley bus costs were significantly higher. Cable cars required two men—a gripmen and conductor—buses only a single operator. Both the Washington-Jackson and Sacramento-Clay lines were proposed for abandonment with replacement motor buses. Only Powell-Mason was to be spared.

No tears were shed for the passing of any cable route until a "Save the Cable Car League" was formed in an attempt to save the Sacramento-Clay cable, which became the No. 55 motor coach on February 16, 1942. World War II saved the Washington-Jackson cable line, however.

Between November 1940 and March 1941 and at a cost of about $16,000, the Powell-Mason line's Bay and Taylor turntable was relocated from the middle of the intersection to a new location (today's) 75 yards south on Taylor Street, clear of Bay Street. This change was made to accommodate Golden Gate Bridge vehicular traffic on Bay Street. During construction and installation of a new 19-foot turntable, cable car service was not disrupted!

The City and County of San Francisco took over the Market Street Railway and its two Powell Street cable lines on September 29, 1944. Soon the stage would be set for the cable car wars.

Herb Caen, San Francisco's foremost newspaper columnist, rumored it. Roger Lapham, San Francisco's "infrequently beloved" businessman mayor, confirmed it. Friedel Klussmann, the president of the San Francisco Federation of the Arts, stopped it. The issue was a simple one: should San Francisco keep the city-owned Powell Street cable cars running.

On January 27, 1947, Mayor Lapham, in his annual message to the board of supervisors, declared, "the city should get rid of its cable cars as soon as possible." On March 4, 1947, within sight of Roger Lapham's office, the San Francisco Federation of the Arts and the California Spring Blossom and Wildflower Association held a joint meeting attended by leaders of 27 women's civic groups. Rallied by the impassioned pleas of Friedel Klussmann, they formed the Citizen's Committee to Save the Cable Cars. Lucius Beebe and Charles Clegg were later to write, "It was destined to wield the terror and authority once possessed by San Francisco's Vigilantes of 1851." The issue of the ensuing "Cable Car War" was whether or not Powell Street should be served by "superbuses" instead of cable cars.

Pressure from all over the world was beginning to overtake the mayor and his crowd. Building on this genuine goodwill for the cable cars, Mrs. Klussmann and her committee would succeed in getting a charter amendment on the November ballot to curb the power of the utilities commission and save the Powell Street cables. Visiting celebrities endorsed the cable cars, songs and poems were written, and cable car clothing appeared.

Measure 10, compelling the city to maintain and operate the existing Powell Street cable car system, passed overwhelmingly—166,989 yes to 51,457 no. It was a victory of sentiment and realistic economics—mobilized by the Citizens' Committee to Save the Cable Cars—over cost sheets and opinions of transportation engineers.

Friedel Klussmann's victory statement said it best: "It is wonderful to know that San Franciscans appreciate their famous, efficient and safe cable cars." However, the enemies of the cable cars were not finished.

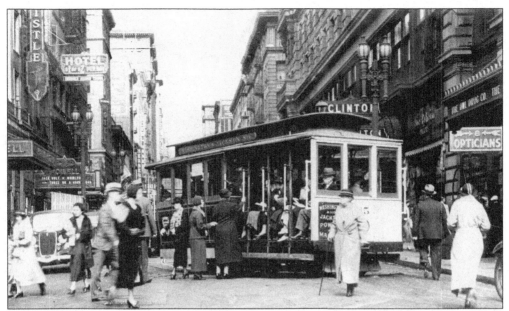

You would not know it by the throng of passengers attracted to Washington-Jackson cable car No. 515, about to be turned on the Powell and Market turntable, that the Great Depression of the 1930s is in the process of destroying much of the economic fabric of the American economy. President Hoover's 1928 campaign promise of "chicken in every pot" seems more of a dream than a reality. (Courtesy Charles Smallwood.)

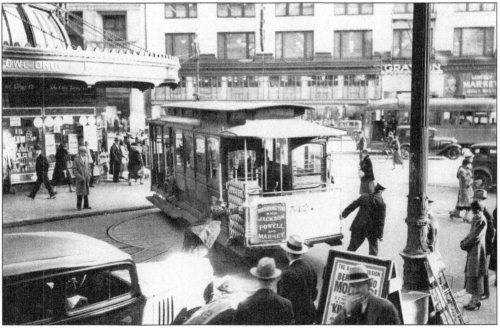

It's 1932, and Herbert Hoover's days in the White House are numbered. Washington-Jackson cable car No. 512 is being turned on the Powell-Market turntable by the manpower of 512's conductor and the Market Street starter, whose responsibility was to ensure that cable cars left Market Street on schedule. Out of view is the gripman, who pushed 512's front. (Courtesy Randolph Brant.)

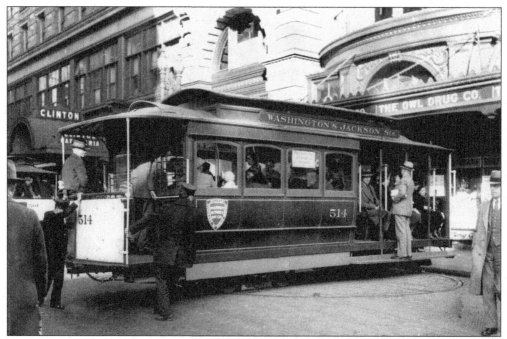

Soon after 514 is turned and pushed off the turntable, the starter will blow his whistle and another Washington-Jackson line trip will commence, 1932. During the 1930s and 1940s, the Owl Drug was a landmark at Powell and Market Street. For many of those years, Monday through Saturday from 12:15 to 12:45 p.m., Owl sponsored on radio station KFRC Dean Maddox's live *Sidewalk Reporter* program. During interviews, the sound of cable car bells could be heard in the background. (Courtesy Randolph Brant.)

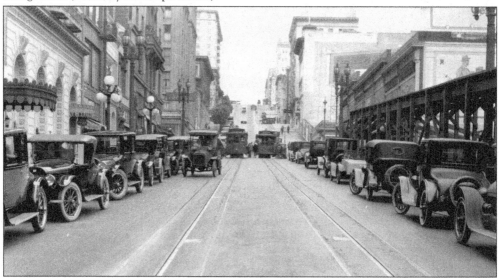

The automobile age definitely has arrived! It's July 1921, and Powell Street between Post and Sutter is lined with public transit's main competitor. Three months previously, on April Fool's Day, the Market Street had taken over the properties of the United Railroads, including the Powell Street cable lines. Powell Street cable cars are still painted in the dark green and red URR colors. (Courtesy Randolph Brant.)

66

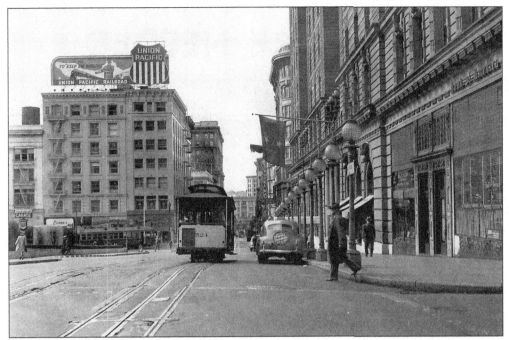

It's a Sunday in 1944, and wartime gas and rubber rationing have temporarily driven automobiles off of Powell Street. Washington-Jackson car No. 524 passes at the St. Francis Hotel. At Geary Street, the Union Pacific Railroad advertises (above) "It's Our Job . . . to 'Keep 'em Rolling.'" A Municipal Railway "C" streetcar heading for the Richmond District. (Courtesy Randolph Brant.)

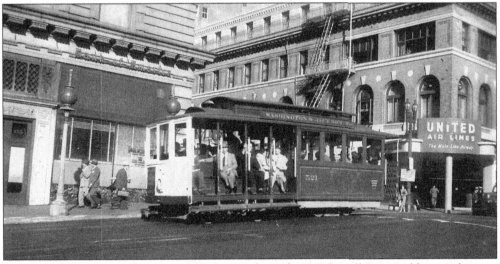

The 7¢ fare that 521 passengers paid for the privilege of a 1942 Powell Street cable car ride was a tiny fraction of the tariff that United Air Lines was charging those who booked tickets at their downtown Post and Powell ticket office. No. 521 (No. 21 from 1973) was judged to be in too poor a condition to be rehabilitated during the 1982–1984 system rebuilding. It was scrapped in 1987 and replaced by a new No. 21 on Dec. 5, 1992. (Ken Kidder photograph; courtesy Emanuel R Mohr.)

MEN ARE NEEDED

AS

GRIPMEN

ON

CABLE CARS

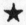

* **Pay $3.00 per day while learning.**
* **Vacation with pay.**
* **Steady work.**
* **Good working conditions.**
* **Company operated Medical Department.**

Start working now for a company furnishing vital transportation to war industries and have a steady job after the war.

MARKET STREET RAILWAY COMPANY
JAMES E. McDEVITT
Supt. of Employment
58 Sutter Street—Room 729

The war is on, and the Market Street Railway is in great need of gripmen. Much of the male labor force is either in the service or working in higher-paying defense industries. Not until January 1998 would Fannie Mae Barnes become the first woman to operate a cable car grip. The 25-day training class had an 80-percent washout rate. No other woman had made it past the first day of training class. (Courtesy Walter Rice.)

"Save a Life. Send YOUR Blood to War NOW" is emblazoned on the sides of No. 510, which is at Powell and Sacramento. World War II is in full force in August 1944. Many blood donors would ride a Washington-Jackson cable car to the Irwin Memorial Blood Bank, the nation's very first community blood bank that then operated out of the basement of the Washington Street Irwin Mansion. (Wilbur C. Whittaker photograph; courtesy Walt Vielbaum.)

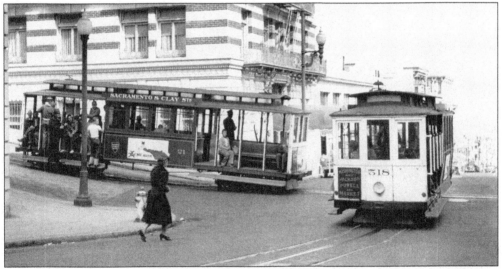

How many riders on inbound Washington-Jackson No. 518 and outbound Sacramento-Clay No. 21, at Powell and Sacramento Streets are aware that two days previously, on August 8, 1941, the board of supervisors voted down the Market Street Railway's petition to convert both lines to motor bus? The basis of the negative vote was Mayor Rossi's request that no further "favors" be extended until the company agreed to make some much-needed street improvements. The Sacramento-Clay line was converted on Valentine's Day 1942, but World War II saved Washington-Jackson. (Jim Carpenter photograph; courtesy Market Street Railway.)

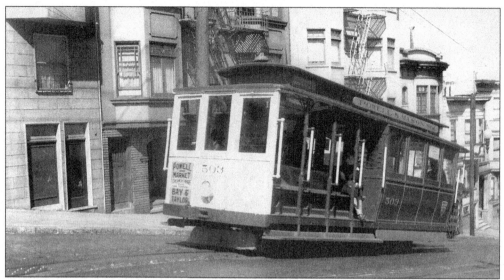

Typical for the period were relatively empty Powell Street cable cars. In April 1939, the Great Depression was not yet over and, more importantly, the Market Street Railway fare was 7¢, whereas the rival Municipal Railway only charged a nickel. To go downtown, many thrifty North Beach San Franciscans had forgone the Powell-Mason cable in favor the Muni's F-Stockton streetcar. Here No. 503 is approaching at Mason and Green Streets the crest of a 17.5-percent grade—the steepest hill on the Powell-Mason line. (Wilbur C. Whittaker photograph; courtesy Walt Vielbaum.)

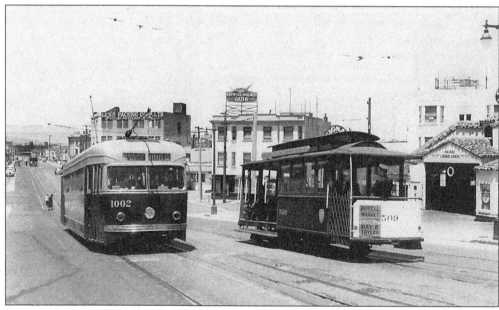

For two blocks on Columbus Avenue, between Mason and Taylor, the Powell-Mason cable car shared the street with Muni's F-Stockton streetcar until 1951. Car cable No. 509, an 1887 Mahoney Brothers product, contrasts with San Francisco's latest rail vehicles as represented by Muni's 1002, a 1939 streamliner, which because of its smooth ride had soon earned the name "magic carpet." (Courtesy Emiliano Echeverria.)

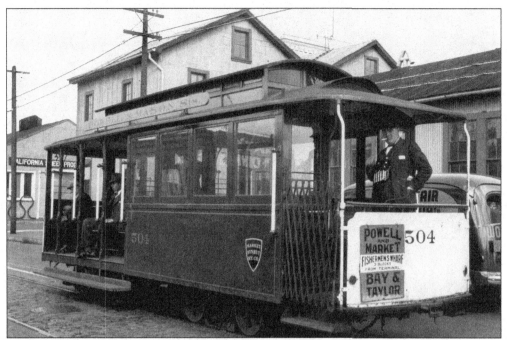

Soon No. 504 will leave Bay and Taylor Streets to make a trip over the Powell-Mason line to Market Street. Originally built as an open car by Mahoney Brothers in 1887, No. 504 was rebuilt in 1915 by the United Railroads into a straight-sided Powell Street combination car, when traffic demands warranted an additional year-round car. In this February 1940 photograph, the conductor appears to be a cable car veteran. (Wilbur C. Whittaker photograph; courtesy Walt Vielbaum.)

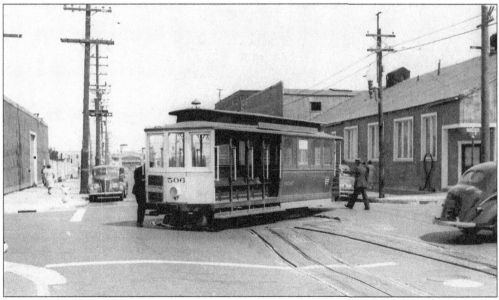

Unlike the crowds that characterize Bay and Taylor Streets today, No. 506 in 1940 is a lonesome cable car. At the end of 1940, thanks to highway funds, the Market Street Railway would start construction to relocate the turntable from the middle of Bay Street to today's location just before Bay Street. (Wilbur C. Whittaker photograph; courtesy Walt Vielbaum.)

The caption from the back of this advertising postcard reads, "Let's have cocktails and dinner at The Cable Car Café (Gary's). It is easy to get to, we ride the Market Street Railway's Powell-Mason cable car to its northern end at Bay and Taylor, and there it is on the corner at 501 Bay Street. If we ride Powell-Mason cable car No. 501, we get a free shrimp cocktail!" ORdway 9688 is the reservation number. (Courtesy Walter Rice.)

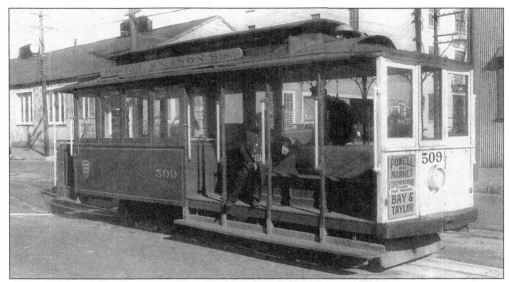

After being reversed on the turntable in the center of Bay Street, Powell-Mason cable cars would be pushed out of the intersection to a safe harbor on Taylor Street, where the crew could enjoy the comfort of a break. The cable car crews of 1940 had an easier job than those of today that encounter continual "crush" loads as well as heavier vehicular traffic that has slowed cable car schedules. (Wilbur C. Whittaker photograph; courtesy Walt Vielbaum.)

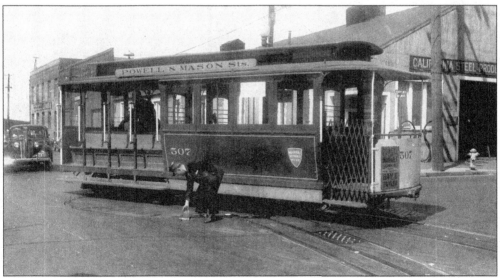

Where where the tourists? In 1938, they had yet to descend in large numbers on the cable car system. No. 507 is on the Bay and Taylor turntable, in what was then a largely industrial section of San Francisco. Ironically it was Mayor Roger Lapham's statement in his 1947 annual message to the board of supervisors declaring, "the city should get rid of its cable cars as soon as possible," that triggered off a nation-wide campaign to save the cable cars. Soon the tourists came. (Wilbur C. Whittaker photograph; courtesy Walt Vielbaum.)

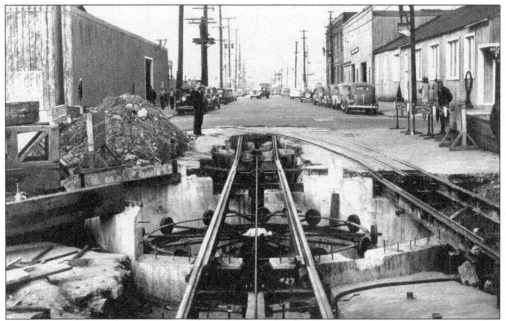

In November 1940, construction began to relocate the Bay and Taylor turntable from the middle of the intersection to a new location (today's), 75 yards south on Taylor Street, clear of Bay Street. This change was made to accommodate Golden Gate Bridge vehicular traffic on Bay Street. In this view, the old turntable is still being used by Powell-Mason cars, but work on the replacement turntable is evident. (Market Street Railway photograph; courtesy Walter Rice.)

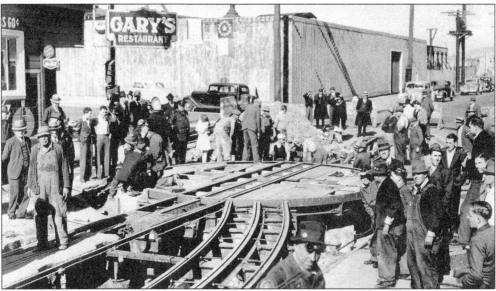

Workers and bystanders wait for a Powell-Mason cable car to roll onto the new Bay and Taylor turntable. The relocation, including the installation of a new 19-foot turntable, took about five months and was completed in March 1941 at a cost of about $16,000. The project was under control of the Market Street Railway's W. D. Chamberlin, who started with United Railroads in 1903 and retired in 1944 on the date of the purchase of the Market Street Railway by the City and County of San Francisco. (Market Street Railway photograph; courtesy Walter Rice.)

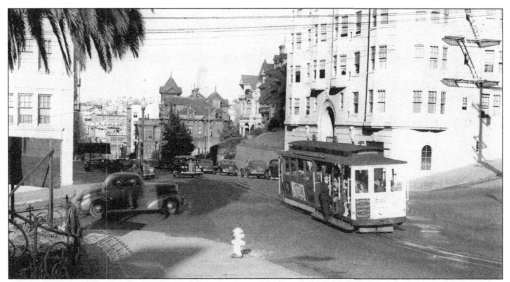

In 1940, a Carter car is westbound on Jacson at Gough on its way to Steiner Street. Today most of the older homes have been replaced by modern apartments. (Wilbur Whittaker photograph; courtesy Walt Vielbaum.)

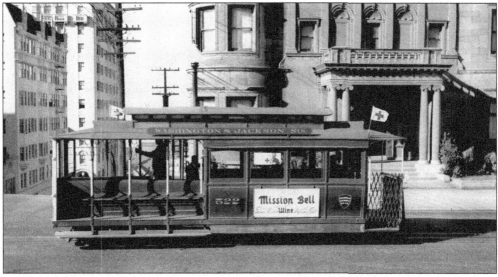

It must be getting close to Christmas time, since Washington-Jackson cable car No. 522 is advertising the seasonal Mission Bell California fruit packs: "Something for the person who has everything." No. 522 is outbound on Jackson Street in the early 1940s, crossing Laguna. The house behind the cable car was the headquarters of the California Historical Society from 1956–1983. (Photograph by Arthur Lloyd.)

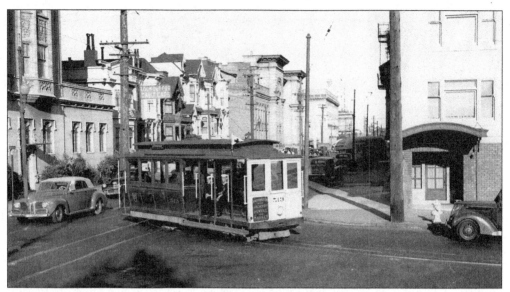

After the 1906 earthquake and fire, the Powell-Jackson cable was shortened to Steiner Street. Electric streetcar took over west of Fillmore. In 1906, to accommodate both cable and streetcars, the United Railroads built new three-rail, dual-gauge, cable-electric trackage on Jackson Street from Fillmore to Steiner. Washington-Jackson car No. 513 has just turned off this trackage on to Steiner Street, 1944. The streetcar tracks of the 3-Sutter-Jackson are in evidence. (Photograph by Arthur Lloyd.)

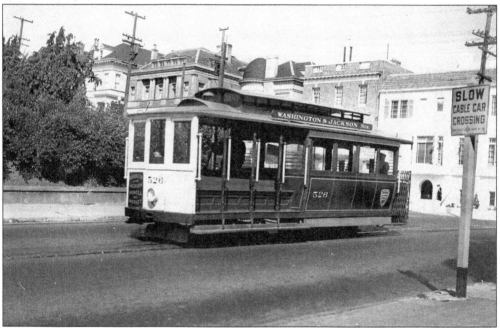

Byllesby control of the Market Street Railway would soon end—a result of the implementation of the Public Utilities Holding Act of 1935. In this September 1937 photograph, as Washington-Jackson cable car No. 526 arrives at its westernmost point, Steiner Street, motorists are warned "SLOW CABLE CAR CROSSING," implying that cable cars and autos have previously collided. (Wilbur C. Whittaker photograph; courtesy Walt Vielbaum.)

76

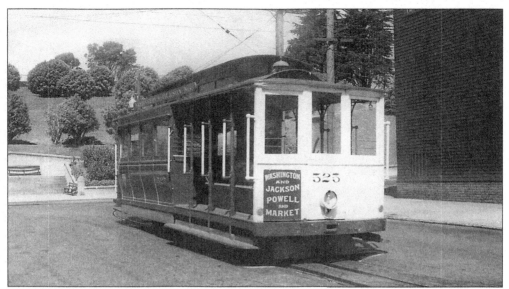

In this August 1940 photograph, Washington-Jackson car No. 525, built between 1888 and 1890 at the Washington-Mason carbarn by the Ferries & Cliff House Railway, has stopped on Washington Street just east of Steiner Street. In the background is the eastern end of Alta Plaza, which then and now is a nice place to meet the aristocratic locals and their dogs. (Wilbur C. Whittaker photograph; courtesy Walt Vielbaum.)

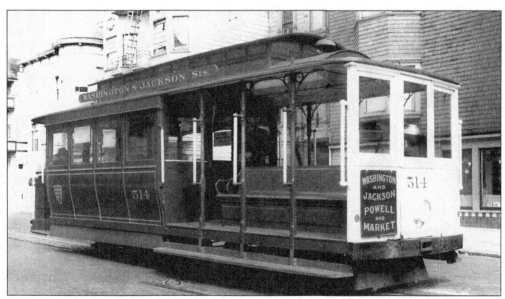

The Washington-Jackson cable cars, as illustrated by No. 514 on July 18, 1940, would take their layover at Washington and Fillmore Streets, one block east of Steiner—the line's western most street. At this location, they would minimize interference with traffic and provide a convenient connecting transfer with passengers from the heavily traveled 22-Fillmore and 16th Streets streetcar. (Wilbur C. Whittaker photograph; courtesy Walt Vielbaum.)

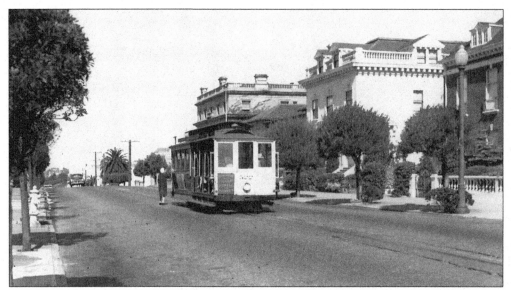

In 1944, the crew of Washington-Jackson No. 522 has kindly stopped, mid-block near Laguna, to board a passenger. Perhaps she is a resident of one of the many Washington Street mansions. The days of Market Street Railway are nearly over. At 5:00 a.m. on September 29, 1944, the City and County of San Francisco will cover the Market Street Railway and its two Powell Street cable lines. (Photograph by Arthur Lloyd.)

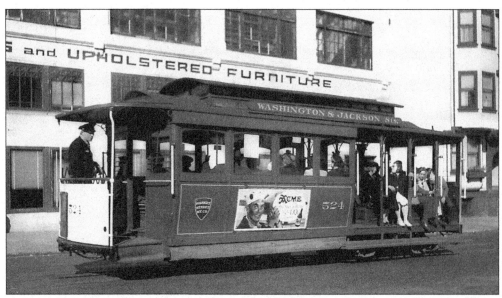

In this February 1944 photograph, inbound Washington-Jackson cable No. 524 advertises San Francisco's Acme Beer, whose brewery was located at Fulton and Webster Streets. Like the Market Street Railway, the brewery faced World War II–material shortages. Even bottle caps were hard to obtain. Acme aided conservation by promoting its quarter-gallon Victory size bottle, which would use one cap instead of three—"Victory Size for the Economy Wise." (Wilbur C. Whittaker photograph; courtesy Walt Vielbaum.)

Most of San Francisco is still shut down by the General Strike of 1934, called by the Harry Bridges and his Longshore union. A lone Sacramento-Clay cable is at the Ferry. When the strike occurred, Samuel Kahn, the president of the Market Street Railway, announced that he "wouldn't ask his men to do anything [he] wouldn't do himself." He then "drove" a streetcar down Market Street accompanied news reporters, the mayor, and the chief of police. It was broadcast on the radio. Kahn's action helped end the strike. (Courtesy Randolph Brant.)

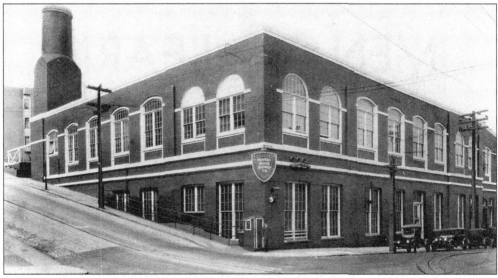

Here is the newly painted (green and white) face of Washington-Mason as it looked in 1928, after Market Street Railway president Samuel Kahn began his campaign to modernize and change public sentiment in favor of the company. Kahn was largely successful, winning voter approval in 1930 for a 25-year operating permit. Other than the application of the famous white-front paint scheme, the Powell Street cable cars were largely untouched by the system-wide upgrade. (Charles D. Miller photograph; courtesy San Francisco Public Utilities Commission.)

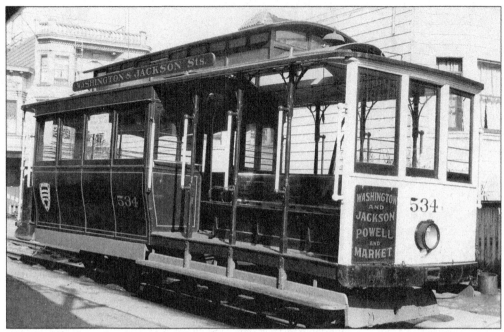

Car No. 534, built by Mahoney Brothers in 1887, models the Market Street Railway's then-new patented white paint scheme at Washington-Mason in 1928. On December 16, 1929, 534 was renumbered to 524—destined to have a historic future. Under sponsorship of the Western Pacific Railroad, it operated at the 1949 Chicago Railroad Fair. Then it traveled to Los Angeles and ran on a rubber-tired truck for the 1950 Shriners convention, representing San Francisco's Islam Temple. On September 2, 1956, No. 524 made the last trip on the Washington-Jackson line. (Charles D. Miller photograph; courtesy San Francisco Public Utilities Commission.)

Not only did the Market Street Railway find itself short of gripmen and conductors during World War II, but ropemen were also in short supply, as the young and the strong were in the service. The Market's pay scale was below that of the many expanding defense industries. On June 1, 1943, the Market Street Railway reported 12 Powell Street cable cars out of service because of an inadequate work force. (Courtesy Walter Rice.)

Five

CABLE CAR
WARS CONTINUE

A NEW LINE

(1947–1957)

The two Powell Street cable car lines, Powell-Mason and Washington-Jackson, were saved. In May 1950, Muni installed a new turntable at Powell and Market Streets. The new turntable replaced the original Ferries & Cliff House Railway (Powell Street Railway) turntable that had been in use since March 28, 1888. During January 1951, Powell cable car 501 (renumbered 28 in 1973, retired January 2004) was completely rebuilt with only the clerestory roof retained. Curved sides replaced the former flat passenger compartment sides. February 1951 saw Mayor Robinson unsuccessfully urge Muni to rehabilitate its Powell Street cable lines, including rebuilding cars, tracks, and the power plant.

On January 7, 1952, the city purchased for $138,785.57 the privately owned and bankrupt California Street Cable Railroad and with it acquired that company's three cable car lines. Within five years, this event would forever change the Powell Street cable operations. The Muni now ran five cable car lines.

At the November 3, 1953 election, two Municipal Railway Rehabilitation bond issues that had monies for cable car system failed to make the two-thirds necessary vote for approval, obtaining only a bare majority. The door was now open for anti–cable car forces to make their move.

The cable car ballot wars continued. At the June 1954 election, voters barely passed Proposition E, which provided for a three-line consolidated cable car system with reduced mileage and operating costs. Under this plan, the Powell-Washington-Jackson line at Hyde Street would turn north on Hyde Street and run to Beach Street instead of continuing west to Steiner Street. In short, it ratified the city a reduction of the former Cal Cable lines. The stage was now set for the present-day system.

Shortly after 1:00 a.m. on September 2, 1956, car No. 524 (now No. 24) made the last trip on the Powell Street's recently rerailed Washington-Jackson line. The shut down was "due to the necessity of installing new track connections and cable installations at Hyde and Washington, and at Hyde and Jackson." This construction was necessary for operation of the future Powell-

Hyde cable and to allow California Street cable cars to operate from the Washington-Mason car barn, instead of the former Cal Cable barn at California and Hyde.

For most of 1957, the California Street cable car line was rebuilt to consolidate it into the Powell Street system's Washington-Mason powerhouse and car barn. Space was available as a result of the Market Street Railway's 1942 conversion of the Sacramento-Clay cable car line.

On April 7, 1957, San Francisco's first new cable car route since the 1891 opening of the O'Farrell, Jones & Hyde line began—the Powell-Hyde cable. The line was created by using the outer section of the Hyde Street leg of Cal Cable's O'Farrell, Jones & Hyde line. A new turntable and trackage were built at the Hyde and Beach terminal to accommodate single-ended Powell Street cars. The new Powell-Hyde line would convert its Hyde and Beach Streets terminal from that of the sleepy area into a major vibrant tourist economic zone.

Early in the morning of December 22, 1957, the California Street line began operation from the Washington-Mason cable car barn. The current three-line, 5.09-mile (one way mileage) cable car system became a reality.

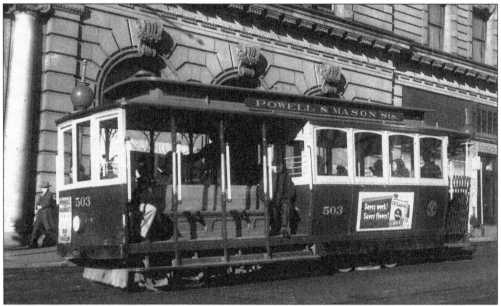

In 1939, the Municipal Railway replaced its traditional grey and red paint scheme with blue and yellow (gold). After Muni acquired the Powell Street cable lines in 1944, three Powell cars were painted in the new owner's colors to advertise the change. Soon Muni adopted cream and green colors that were used on the Powell Street fleet until 1982. No. 503, painted blue and yellow, is passing the St. Francis Hotel in 1947. (Ken Kidder photograph; courtesy Emanuel R. Mohr.)

Sporting the blue and yellow colors that Muni borrowed in 1939 from the University of California as the railway's colors, No. 503 was one of three Powell cars fully painted in the mid-1940s in these colors, before railway adopted cream and green as its official colors. Looking a little worse for wear in 1947, a totally empty 503 has just been pushed off of the Bay and Taylor turntable. The lack of crowds was typical of the period. (Estacaille photograph; courtesy BAERA Archives #24363.)

In 1927, Market Street Railway president Samuel Kahn received a patent for the "white front" as a safety feature. After Muni's 1944 purchase of the Market, the Muni was required to pay to the former owner a daily royalty for each white-front car. Muni's then blue and yellow colors were applied to No. 506's front to avoid the royalty. No. 506, shown here crossing California Street in 1946, was the sole car to have only its front painted, as soon all Powell cars would be entirely repainted. (Savage photograph; courtesy BAERA Archives #10341.)

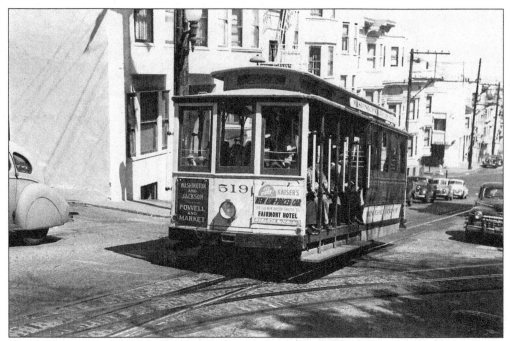

How many of 519's passengers are returning from the Fairmont Hotel's preview of Henry Kaiser's new low-priced car, the Henry J? Bound for Steiner Street, No. 519 is ascending the 15.2-percent Jackson Street hill west of Mason Street, 1950. The track curving off allows cars to stop and coast backward into the Washington-Mason car storage area. (Wilbur C. Whittaker photograph; courtesy Walt Vielbaum.)

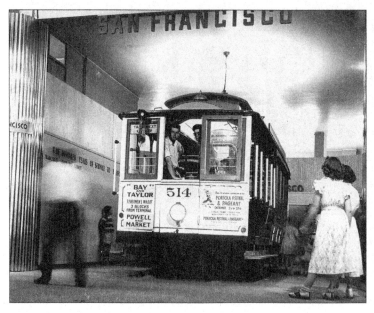

Winner of a ribbon for San Francisco at the 1948 California State Fair, Powell Street cable car No. 514 is being inspected by two youths, while their bobby-socked dates admire their bravery. At the time, No. 514 was assigned exclusively to the Washington-Jackson line, but for the Fair it is signed for the Powell-Mason cable—the most famous the two Powell Street cable car lines. (Photograph by Walt Vielbaum.)

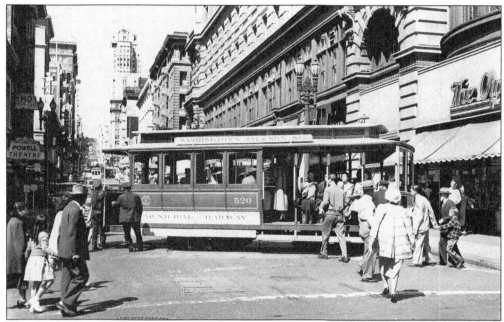

San Franciscans boarding Washington-Jackson cable car No. 520 at Powell and Market Streets are probably unaware that No. 520 (now 20) had recently costarred with Humphrey Bogart in the 1947 movie *Dark Passage*. Bogart, an escaped convict who has had plastic surgery, rides 520 as he cavorts around San Francisco. (Photograph by Walt Vielbaum.)

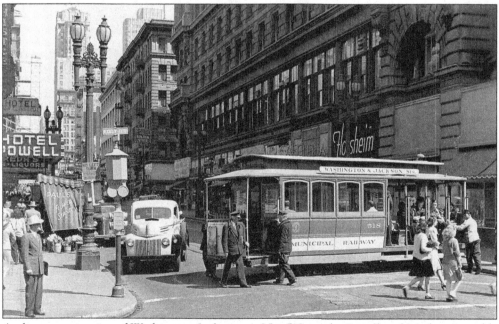

A close examination of Washington-Jackson car No. 518 on the Powell and Market turntable reveals that the car does not have the standard dash sign of that line, but one that reads "Jackson and Mason Streets Only." In the late 1940s, Muni rerailed parts of Jackson and Washington Streets west of Hyde Street. During construction, Washington-Jackson cars served only the inner half of their route. (Courtesy Emiliano Echeverria.)

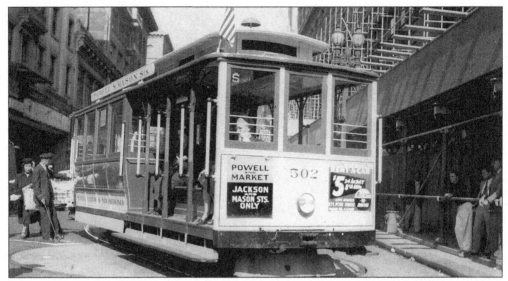

Between September 17, 1950, and October 28, 1951, Powell-Mason ran only to Jackson and Mason Street because of construction of the cable-car-track overpass at the Broadway Tunnel site. Car 502, signed for this abbreviated service, is heading for the Powell and Market turntable. (Wilbur C. Whittaker photograph; courtesy Walter Rice.)

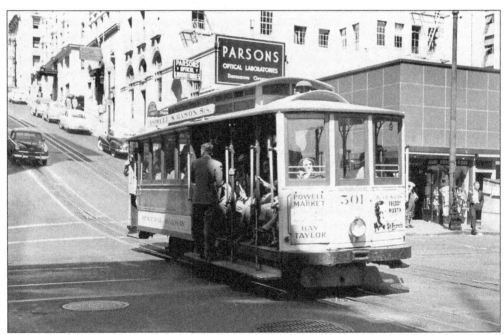

Powell-Mason car No. 501 crosses Sutter Street in 1950, during its last few months of operation before it was sent to Muni's Elkton Shops for a major rebuilding. When it emerged from the shops, only its roof, seats, bulkheads, and hardware would be retained. Its straight-sided, enclosed passenger compartment would be replaced with the traditional curved sides. (Photograph by Walt Vielbaum.)

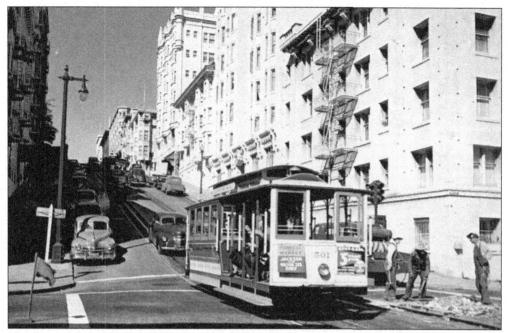

Car 501 (a.k.a. No. 28), fresh from an extensive rebuilding at the Elkton shops, signed for the abbreviated Jackson Street–only service during Broadway Tunnel construction, is heading down Powell Street at Bush. (Courtesy Emiliano Echeverria.)

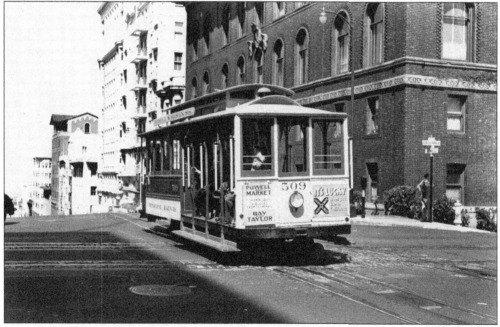

Passengers and crew of No. 509, as it crosses in the early 1950s the California Street cable car line, are undoubted unaware that No. 509 was originally one of three open cars that survived the 1906 holocaust. Later it was rebuilt into a standard Powell Street combination car, and in the 1950s it was rebuilt again, with curved enclosed passenger compartment curved sides. (Photograph by Walt Vielbaum.)

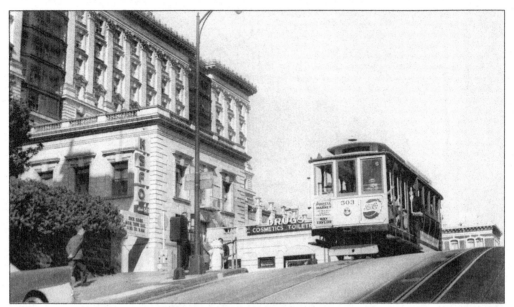

In this 1957 photograph, No. 503 has just coasted across the California Street cable line and, with the aid of a dip in the track, again picked up the cable before descending down Powell Street. When the grip is fully applied to the cable, the cable itself is a brake—the car cannot go faster than the cable, even on the steepest hills. (Courtesy Walter Rice.)

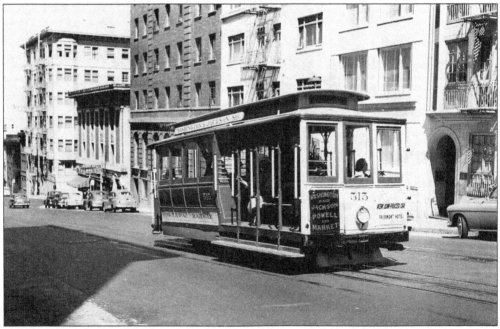

Washington-Jackson cable car No. 515, an 1894 product of the Carter Brothers, heads toward Market Street as it approaches Sacramento Street in the early 1950s. The light passenger load was indicative of the period and contrasts sharply with today's heavy ridership pattern. (Photograph by Walt Vielbaum.)

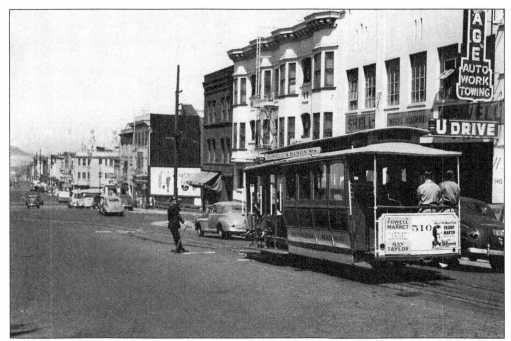

Outbound Powell-Mason and Washington-Jackson cars moved to their unique trackage on Powell Street just before they turned west onto Jackson Street. The conductor of No. 510 is holding the up the switch lever to set the switch for the Powell-Mason car. Washington-Jackson conductors had no such duty, since the switch was set for that line. (Photograph by Walt Vielbaum.)

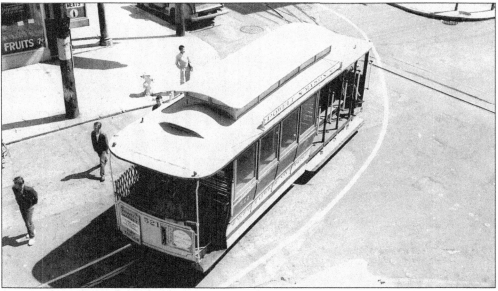

Market Street–bound Powell-Mason cable car No. 521 has "let go" of the Mason rope and is coasting around the corner from Mason onto Washington Street. Near Powell Street, a dip in the tracks will bring the open jaws of its grip down to the Powell Street cable, allowing No. 521 to continue. No. 521 is seen from the car storage area of the Washington-Mason carbarn in this unique 1980 photograph. (Courtesy Walter Rice.)

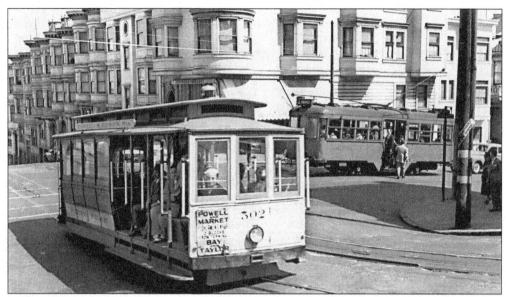

Inbound Powell-Mason No. 502 has just crossed the tracks of the Municipal Railway's E-Union streetcar line, once a cable car line. In 1922, the Muni purchased 21 single-truck center entrance streetcars that featured two braking systems to accommodate the Union Street hills. In the background of this 1947 photograph, a Presidio-bound E-car loads passengers. (Courtesy Walter Rice.)

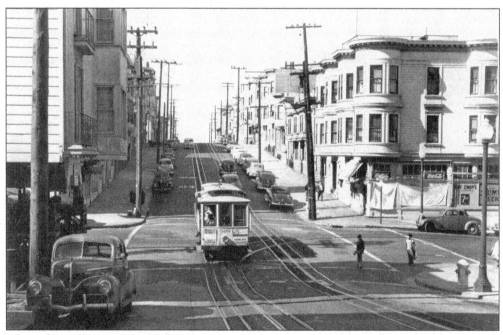

Inbound Powell-Mason No. 508 has just crossed Broadway in this 1949 photograph. Curving south onto Mason Street is a single standard-gauge electric car track that was used in both directions by electric work cars hauling oil, parts, and—yes, cable cars to and from the Washington-Mason car and powerhouse. Both the cable cars and electric cars shared the inside running rail. This electric trackage was used from 1901 to February 1950. (Photograph by Walt Vielbaum.)

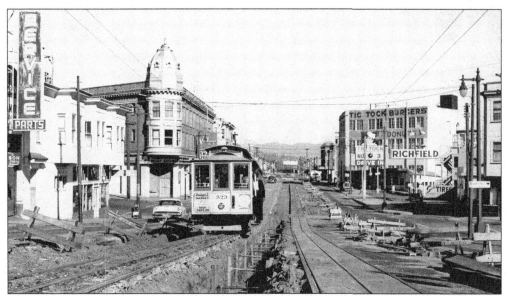

Between 1914 and 1951, the Powell-Mason line shared its two-blocks on Columbus Avenue with Muni's F-Stockton streetcar. It has been three years since the F had become the 30-Stockton trolley bus. The city is finally removing the unused streetcar tracks. During the 1982–1984 rebuilding, the cable car tracks were relocated to the outside lanes so that fast-lane vehicle traffic would not be slowed the cable speed of 9.5 miles per hour. (Courtesy Walter Rice.)

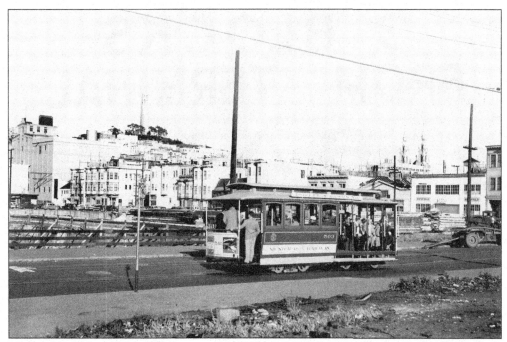

Market Street–bound Powell-Mason car No. 503 has just left its Bay Street terminal (one block behind) as it approaches Francisco Street in 1950. Under construction is a 1950s-style public housing project that would be deemed undesirable and torn down and replaced in 2004. (Photograph by Walt Vielbaum.)

The famous yellow-and-white dash sign of the Powell-Mason cable car alerted tourists that Fisherman's Wharf was only three blocks from terminal. This dash sign was a product of the ownership of the Market Street Railway (of 1921) and its president Samuel Kahn's desire to upgrade the image of the company. (Photograph by Walter Rice.)

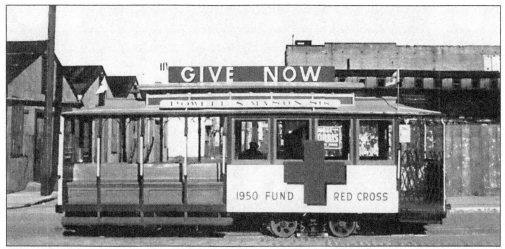

The 1950 Red Cross drive is on, with the support of this Powell Street cable car. During the late 1940s and early 1950s, one the four flat-sided Powell cars was outfitted with signage encouraging San Franciscans to support this worthy charity. Once all of the flat-sided cars had been rebuilt to the standard curve-side configuration, this type of signage was impossible. (Courtesy Walter Rice.)

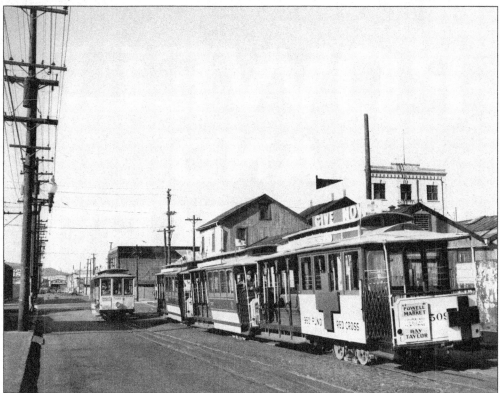

During the late 1940s and early 1950s, straight-sided Powell-Mason car No. 509 became a mobile billboard for the annual Red Cross drive. No. 509 is third in line for the Bay and Taylor turntable, as No. 508 is about to depart for Nob Hill, Union Square, and city's retail core. (Photograph by Walt Vielbaum.)

Since the outer end of the Washington-Jackson cable car did not serve a major tourist destination, its dash sign text simply stated in yellow letters on a dark green background: "Washington and Jackson, Powell and Market." (Photograph by Val Lupiz.)

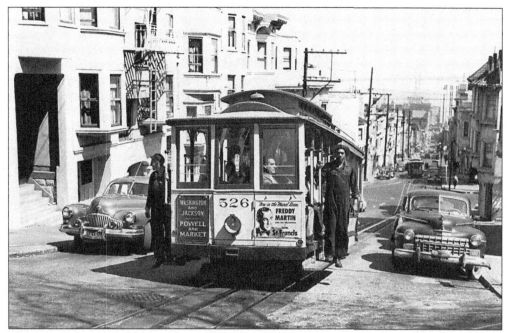

The Mural Room of the St. Francis, featuring the Freddy Martin Orchestra, is promoted on Washington-Jackson No. 526, which is about to pass the Jackson Street pull-in gate to the Washington-Mason carbarn car storage area, in 1950. In a few feet, the two Muni workers in overalls will jump off the car to attend to their barn duties. (Photograph by Walt Vielbaum.)

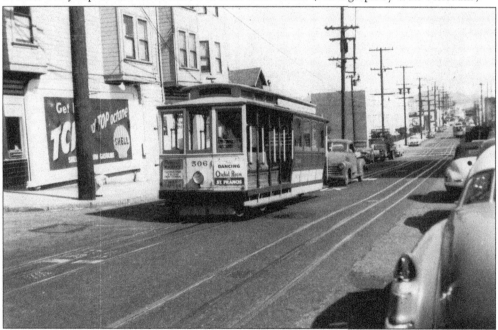

Another Mason car is on its way downtown from North Beach, pictured around 1955 at Taylor and Columbus, looking toward Fisherman's Wharf. This scene looks much the same today, except for the disappearance of the housing projects in 2001–2003. North Beach is itself a major destination, while the Wharf area has expanded. (Photograph by Kenneth Clyde Jenkins.)

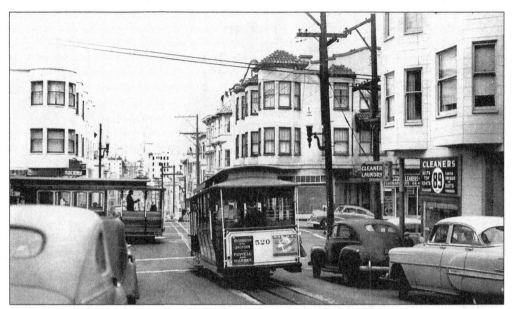

In 1953, Steiner Street–bound Washington-Jackson cable car No. 520 has stopped at Hyde Street to allow a former California Street Cable Railroad, now part of the Municipal system, O'Farrell, Jones & Hyde Street outbound cable car to have the right-of-way. Within four years, outbound Jackson Street cars will be turning right onto Hyde Street. (Courtesy Emiliano Echeverria.)

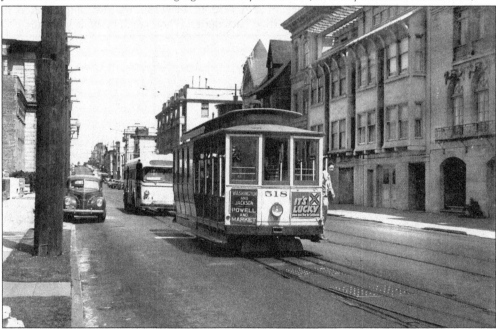

A famous slogan of the 1940s and 1950s was "It is Lucky when you live in California." In 1949, San Francisco–based breweries still dominated the local market. Local brewery dominance and the Washington-Jackson cable were both destined to become legend. No. 518 is turning off of Jackson Street onto Steiner Street. Ex-Market Street Railway bus No. 164 provided a shuttle service that connected with now–cut back to Sutter and Fillmore Streets 3-Jackson streetcar. (Photograph by Walt Vielbaum.)

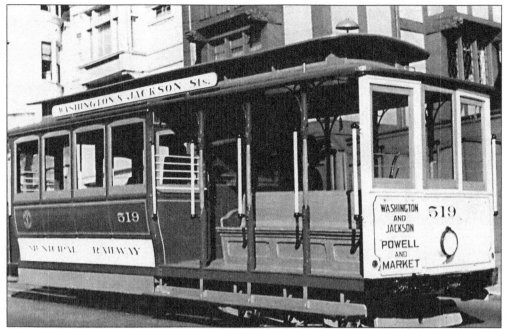

When Muni adopted green and cream as its official colors, the first Powell Street cable car to appear in the new paint scheme was No. 519, assigned to Washington-Jackson. Here in February 1946, No. 519 shows off the new fleet colors on Steiner Street. The experimental cream dash sign with green letters was never adopted; the color scheme remained yellow letters on a green background. (Courtesy Walter Rice.)

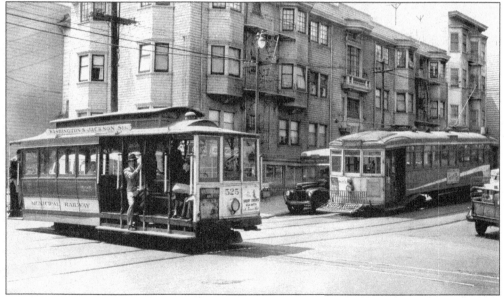

Both Washington-Jackson cable car No. 525 and 22-Fillmore streetcar No. 869 were built by their former operators. No. 525 was an 1888 product of the Ferries & Cliff House Railway's Washington-Mason facility, and 869 was turned out by Market Street Railway's Elkton shops in 1927. No. 525, as No. 25, is still on San Francisco's streets, while 869 met the scrapper in 1948. Their paths crossed in 1947 at Washington and Fillmore. (Photograph by Walt Vielbaum.)

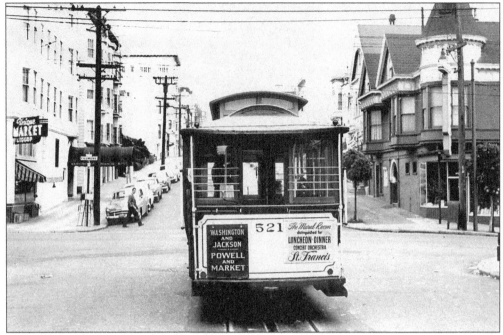

Washington-Jackson cable No. 521 is taking its layover at Washington and Fillmore before returning to Powell Street and the heart of San Francisco in August 1953. A close examination of No. 521's roof shows the classic styling of a Bombay roof that featured at both the front and back a "hump" or "eyelid." (Photograph by Walt Vielbaum.)

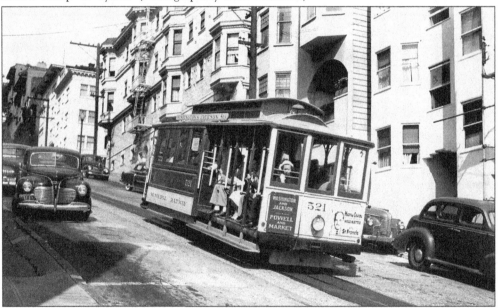

A sign on No. 521 advertises that Harry Owens's "Royal Hawaiians" with Hilo Hattie are entertaining at the St. Francis in 1949. This was the era when it was status for San Franciscans to cruise to the Hawaiian Island on the S.S. *Lurline*. These San Franciscans are enjoying a more routine trip, but nevertheless an exciting journey, as No. 521 descends the 13.8-percent Washington Street grade from Jones Street. (Photograph by Walt Vielbaum.)

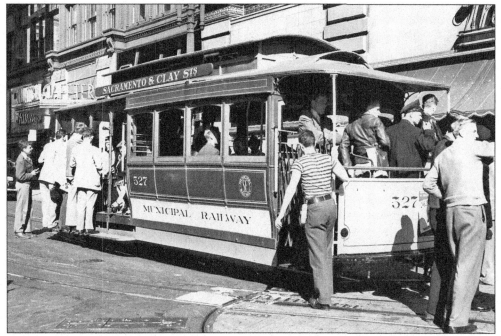

Two days before the November 4, 1947 election that "saved" the Powell Street cable cars, members of Friedel Klussmann's Citizens' Committee to Save the Cable Cars pile on chartered Powell car No. 527 at the famous intersection of Powell and Market Streets. No. 527's signage is that of the abandoned (in 1942) Sacramento-Clay line cable, as a warning to the voters of a similar fate for the Powell lines if the cable car measure lost. (Photograph by Walt Vielbaum.)

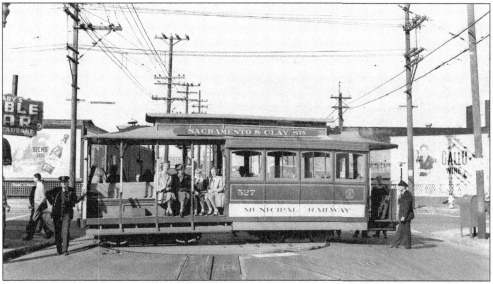

Most of the members of the Citizens' Committee to Save the Cable Cars have temporarily deserted their chartered campaign cable car, as it is being turned on the Bay and Taylor turntable, but not Friedel Klussmann (seated in the center), who is enjoying every moment of her cable car ride. Two days later, November 4, 1947, her joy would be at an apex as the voters would overwhelmingly vote to save the Powell cables. (Courtesy Walter Rice.)

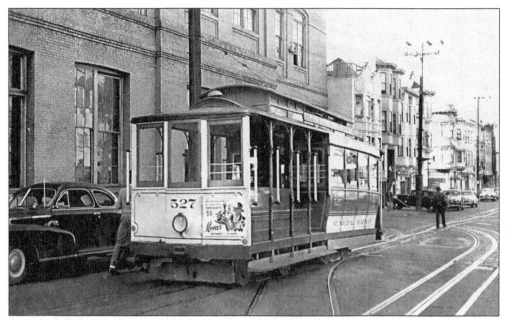

The Citizens' Committee to Save the Cable Car campaign to compel the city to maintain and operate the Powell Street cable cars, special charter car No. 527 has just completed touring the Powell lines in support of Measure 10. Needless to say, the effort was successful. Now it is time for No. 527 to coast into the car house and wait for its next assignment—a routine one on the Washington-Jackson line. (Ken Kidder photograph; courtesy Emmanuel R. Mohr.)

With a smiling Friedel Klussmann looking on, Mayor Elmer Robinson rings a cable car bell as part car No. 524's sendoff to the Chicago Railroad Fair, 1949. Robinson had been elected largely because of his pro–cable car platform. "My whole heart is for the cable cars." However, before the mayor left office in 1955, the city's cable car mileage was significantly reduced, notably the lines of the former California Street Cable Railroad. (Courtesy Rudy Brandt.)

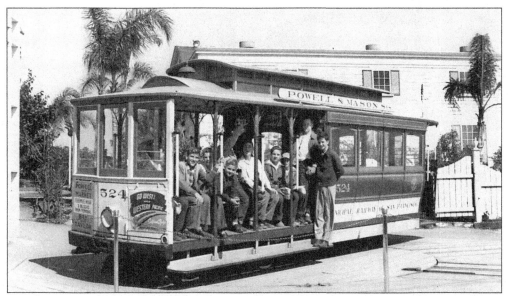

Powell cable No. 524 holds the record for the longest cable car journey. Under the sponsorship of the San Francisco–based Western Pacific Railroad; No. 524 ran on a short section of track at the 1949 Chicago Railroad Fair. To delight of fair-goers, two Powell gripmen and one gripman from the California Street Cable Railroad were sent to Chicago run No. 524. (Courtesy Walter Rice.)

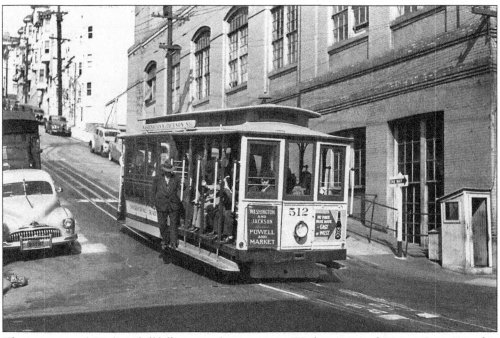

The gripman of 512 has skillfully coasted to a stop at Washington and Mason Streets in this 1949 photograph. He had to "let go" of the cable (being attached to the cable acts as a brake) as 512 passed the rear of the Washington-Mason cable carbarn and powerhouse. At that point, the Washington-Jackson cable entered the powerhouse. (Wilbur C. Whittaker photograph; courtesy Walt Vielbaum.)

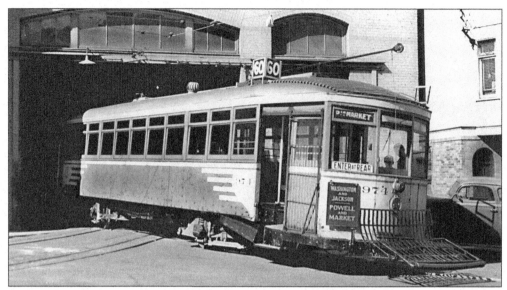

In 1901, the Market Street Railway (of 1893) added a third running rail to the west side of Mason Street's cable trackage creating a standard-gauge (4 feet, 8½ inches) electrified connection between Washington-Mason and the electric railway system at Broadway, two blocks north. This trackage allowed for fuel oil movements and the hauling on flatcars to the company's shops of cable cars. Shortly before the February 1950 abandonment of this electrification, Muni-chartered streetcar No. 974 is emerging from the barn. The signage "60" refers to the route number Muni assigned to the Washington-Jackson cable car. (Courtesy Richard Schlaich.)

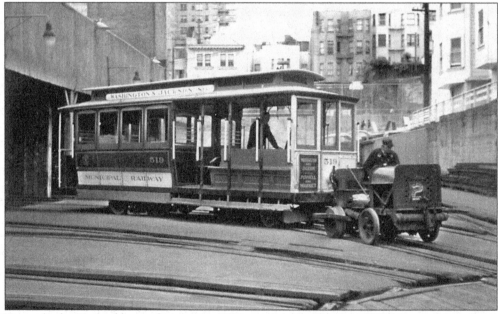

Four-cylinder Ford cable car shunter No. 010 is towing No. 519 out of Washington-Mason's car storage area to the barn turntable, where 519 will be turned 180 degrees and then pushed to the Washington Street exit. Like all Powell Street cable cars, 519 will enter service by coasting onto Washington Street. Before the motorized shunter, horses and manpower moved the cable cars in the barn area. (Photograph by Dudley Westler.)

Before entering service No. 527 is having a new grip installed. Since the 1920s, Powell Street cable cars have had a grip removal door in the middle of their front end that allows easy access for the replacement of the over-300-pound grip. Grip replacement is common occurrence because of the continual wear and tear. Typically grips are replaced at least once a week. (Photograph by Walt Vielbaum.)

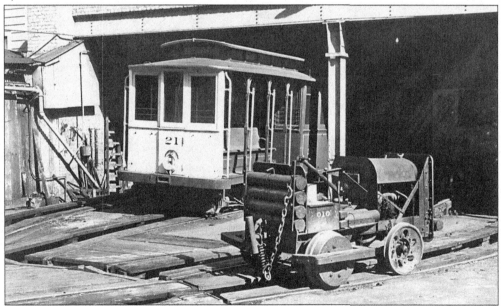

In 1947, Washington-Mason cable car shunter rests from its duties of pushing and pulling powerless cable cars in the car storage area, while out-of-service former Sacramento-Clay cable car No. 21 pokes an end out from its storage track. Since World War II was raging in 1942, when the Sacramento-Clay was abandoned, the federal government ordered that all Sacramento-Clay cable cars be retained. Muni shortly will be disposing of No. 21. (Photograph by Walt Vielbaum.)

Both the gripmen of Washington-Jackson cars Nos. 517 and 527 have received a green light from the signal tower man (far left of picture) to proceed across to the tracks of the California Street cable line. In order to avoid a cable car from both Powell and California Streets entering the intersection at the same time, a signal tower man controls the cable car movements. The signal is always red until the "Towerman" gives the green "Go" signal. (Courtesy Rudy Brandt.)

At the June 8, 1954 election, voters barely passed Proposition E that authorized the current three-line, consolidated cable car system. As part of this consolidation, the Washington-Jackson line in 1956 was on borrowed time. The clock was ticking. That September, the line would end, being replaced the following April by the new Powell-Hyde cable. Soon the scene at California and Powell itself would change. The Fairmont Hotel would erect a high-rise addition next to the intersection. (Courtesy Walter Rice.)

Six

A Physical Collapse and Rebirth

(1957–2005)

To commemorate the 50th anniversary of the San Francisco's Municipal Railway in 1962, a "new" cable car (second), No. 518 (now 18), was placed into service. It was built in 1961, almost entirely new except for some spare parts. No. 518 was the first new cable car to enter service since the Muni's 1944 purchase of the Market Street Railway and was the first passenger car to be built by the Muni (other than the Hetch Hetchy Railroad motor cars) since its inception in 1912.

On January 29, 1964, the cable car system was designated a national historic landmark. The official ceremony was held that October 1 at Hyde and Beach, presided over by Chief Justice (and former California governor) Earl Warren. The cable car system was now included on a select list of moving historic landmarks.

As San Francisco entered the mid-sixties, change was afoot. On February 2, 1965, Mona Hutchin, a University of California student, refused to leave her standing position on the outside front steps of Powell-Hyde car No. 521 (now 21) after the car had been pushed off of the Powell and Market turntable. The police were called and removed her only to discover that there was no legal basis for such a policy. That spring, 92 years after the cable cars' debut, the unofficial ban against women standing on the outside cable car steps was lifted.

Neither cable car advocates nor anyone else could forestall the deterioration of the system. By the mid-1970s, time and constant use were overcoming maintenance efforts. In late September 1979, the entire cable car system was found to be unsafe. The repairs were only stopgap measures. By then, a total rehabilitation of the system was required, including the channels, tracks, and pulleys, and the entire barn and powerhouse. September 21, 1982 was the last day of cable car service, and the day after the last Powell cable car No. 7 pulled into the Washington-Mason car barn, the $57.5 million Cable Car System Rehabilitation Program started.

Sixty-nine city blocks of old tracks and cable channels were removed, replaced, and upgraded. The Washington-Mason carbarn and powerhouse was completely rebuilt, except for the chimney (that dates from 1887) and exterior walls, which were retained (and reinforced) so that the

building's traditional appearance could be preserved. The ladder track in the car storage area was enclosed, as it had been in the original 1887 barn.

Curves were banked and their radiuses increased to enhance passenger safety. The gripman's cry of "'cout for the curve" (the often-used version of "look out for the curve") became almost obsolete. New heavier rails became uniform throughout (some of the rail on Powell Street was former horsecar rail from the 1880s). The Powell-Mason trackage on Columbus Avenue was moved from the street's center to the outside lanes to improve traffic flow. Four new turntables were put into service. The Powell Street fleet now sported a maroon, light-blue, and white scheme reminiscent of the colors of the original 1887 Powell Street Railway (only No. 3 was kept in the former green and cream colors).

"They're Back!" the headline of the *San Francisco Examiner* informed the world. On June 21, 1984, San Francisco held festivities celebrating the return of the city's full three-line cable car system, beginning with a ribbon-cutting ceremony at Union Square and followed by a parade of cable cars up Powell—the world's most famous cable car street.

Since the cable cars again began to traverse San Francisco's streets, Muni has not only continued its upgrade program, but improved upon it. On April 10, 1990, the rebuilding of Powell Street Cable Car No. 16 was celebrated with a parade on Powell Street, ceremony, and entertainment. Car No. 16 is painted in the blue-and-yellow scheme Muni used between 1939 and 1946. Two Powell cars had this scheme for a brief time after Muni acquired the Powell lines in 1944.

On December 5, 1992, Muni introduced to the public three brand-new cars: Powell cars Nos. 13 and 21 and California car No. 49. No. 13 is painted in green with a red-trim paint scheme similar to the colors of its former operator, United Railroads. On September 15, 1994, new Powell car No. 4 was placed into revenue service after a public welcoming ceremony at the Powell and Market turntable. On April 24, 2000, new Powell Street cable car No. 9 entered revenue service painted in a green and white paint scheme similar to the colors of the Market Street Railway, the operator of the Powell Street cable cars from 1921 to 1944.

Each of these new Powell cable cars are made of wood, glass, brass, and steel and take about 18 months at a cost of approximately $450,000 (2005) to build. They are a tribute to the skills of the Muni craftspeople. Although most of the construction practices are the same as the original car builders, Muni craftspeople have made many improvements, such as in the finish of the wood and the fit of the joints on the cars. Given the care that is taken in building today's cable cars, it is easy to see why the cars have been called the finest cable cars ever built.

New turntables have been again put into service. On June 25, 2001, a new turntable was placed into service at Powell-Hyde line's turnaround, "Friedel Klussmann Memorial Turnaround," at Hyde and Beach Streets. The turnaround had been officially named in honor of the "Cable Car lady" on December 1, 1997. A new $500,000 turntable at Powell and Market Streets was installed during the fall of 2002, featuring extra ball bearings to make it turn easier. In October 2004, the Mason leg of the Powell-Mason line was shut down while the Bay and Taylor turntable was also replaced. Other ongoing renewals are a continual activity. Continual upgrades and recognition of the cable car system will ensure that this invaluable asset will be part of San Francisco for future generations.

Each year, the popular Cable Car Bell Ringing contest between cable car crew members is held at Union Square. During the Christmas holiday season, some of the Powell Street cable cars are adorned with seasonal decorations. The employees of the Cable Car Division have annually hosted a Christmas luncheon for San Francisco seniors.

In the 21st century, the Powell Street cable cars, as before, are an integral part of the city's economic base. San Francisco realizes that the cable cars have benefits far beyond their sentimental value. The little Powell Street hill-climbing cars are the symbol of the San Francisco. What tourist would come to San Francisco to ride a Powell Street bus? Cable car lovers and business owners owe a debt of gratitude to Friedel Klussmann, who said "no" to forces of "progress."

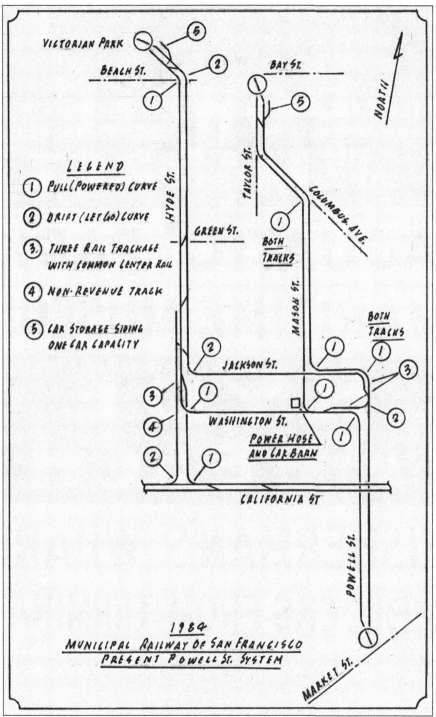

LEGEND
① PULL (POWERED) CURVE
② DRIFT (LET GO) CURVE
③ THREE RAIL TRACKAGE WITH COMMON CENTER RAIL
④ NON-REVENUE TRACK
⑤ CAR STORAGE SIDING ONE CAR CAPACITY

1984
MUNICIPAL RAILWAY OF SAN FRANCISCO
PRESENT POWELL ST. SYSTEM

Here is today's cable car system, reflecting the last change to the Powell Street operation. In 1957, the Washington-Jackson line west of Hyde Street was turned north on Hyde Street using the former outer Hyde Street tracks of the California Street Cable Railroad's (Muni from 1952–1954) O'Farrell, Jones & Hyde line, creating the Powell-Hyde line. (Map by Don Holmgren.)

The dash sign for the new Powell-Hyde line featured its Hyde Street processor cable car line, Cal Cable's O'Farrell, Jones & Hyde line. The new line served Aquatic Park and came within four blocks of Fisherman's Wharf. (Courtesy Walter Rice.)

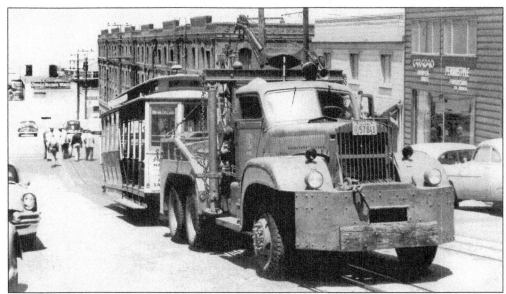

The new trackage to convert Hyde Street north of Washington Street has been completed for the opening on April 7, 1957, of the new Powell-Hyde cable car line. Hyde Street will see single-ended Powell Street combination cars. Powell car No. 507 (now No. 7) was the first single-ended cable car on Hyde Street (even before the cable was powered). No. 507, as shown here, was towed to check the Hyde Street track work, including the new turntable and its trackage at Hyde and Beach. (Courtesy Walter Rice.)

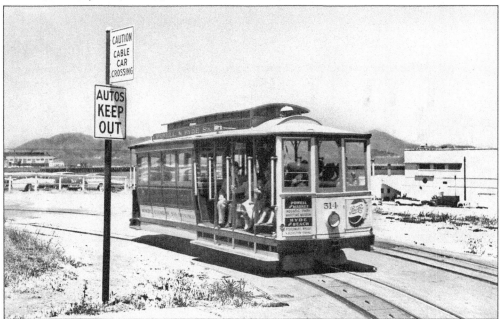

Pictured in June 1959, Powell-Hyde car No. 514 is leaving its relatively deserted Hyde and Beach Streets Aquatic Park northern terminal. Within a few years, the Powell-Hyde cable will transform the area into a vibrant tourist location, Aquatic Park will be landscaped to truly become a park, and the cable car turntable area will be named "Freidel Klussmann Memorial Turnaround" in honor of the "cable car lady." (Photograph by A. Thoman.)

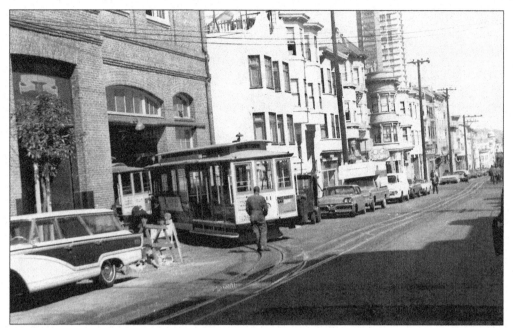

Cars 514 and 525 have coasted backward from Mason Street to enter the Washington-Mason carbarn in 1973. Once inside, an elevator will take them to the upstairs car storage area. Today car barn–bound cars, after leaving Mason Street, climb halfway up the Jackson Street hill to enter directly into the storage area by switching and coasting backwards. (Courtesy Rudy Brandt.)

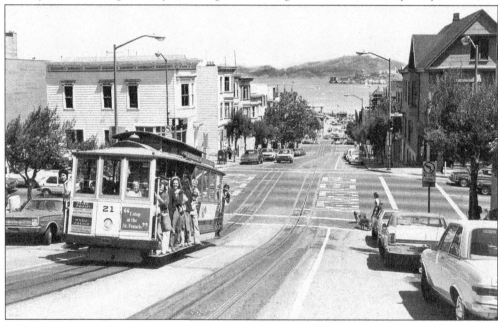

Muni's first No. 21 has just crossed Bay Street and started its climb up the Hyde Street hill to crest at Russian Hill. The first No. 21 was built by Mahoney Brothers in 1887 and numbered 521 until 1973. It was judged to be in too poor a condition to be rehabilitated in the 1982–1984 rehabilitation program and was scrapped in 1987. A new Muni-built No. 21 was dedicated on Dec. 5, 1992. (Photograph by Walt Vielbaum.)

August 2, 1973 was a joyous day for San Francisco—its beloved cable car system was 100 years old. On Clay Street a century previously, Andrew Hallidie had successfully tested the world's first cable car. Crowds cheer as decorated Powell cars Nos. 6, 24, and 27 pass the St. Francis Hotel. (Photograph by David Banbury.)

The car storage area ladder tracks were outside at the second Washington-Mason carbarn (1907–1982). Car 509 rests on the barn's turntable after coasting backwards from Jackson Street, before shunter 010, a Model A Ford, will push No. 509 into its storage track to rest for night. (Photograph by Ray Long.)

Car No. 1 is stopped in front of the St. Francis Hotel during the 100th Cable Car Anniversary parade of August 2, 1973. No. 1 was built at Muni's Elkton Shops as the Centennial Car to celebrate 100 years of San Francisco cable cars. It was completed on May 2, 1973, with the roof and seats from first No. 506. No. 1 has a plaque honoring Friedel Klussmann. (Photograph by David Banbury.)

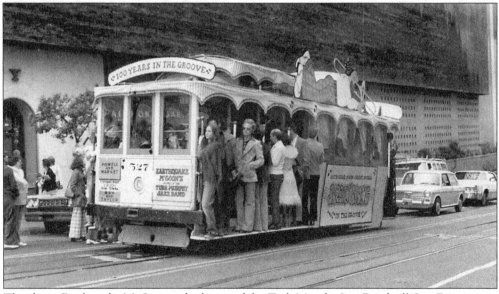

Thanks to Earthquake McGoons, the home of the Turk Murphy Jazz Band, all San Francisco is informed that its cable cars have been "100 Years in the Groove." No. 527, an 1887 product of the Mahoney Brothers, is very close to the crest of Powell Street at California Street. Soon No. 527 will be renumbered to the number it carries today No. 27. (Courtesy Walter Rice.)

New rail over the completed conduit, which carries the cable, is being installed on Powell Street between Ellis and O'Farrell. Prior to the rebuilding, the various sections of Powell Street rail came from many sources—even recycled light-weight horsecar rail. During the Depression years of the 1930s and the war years of the 1940s, the Market Street Railway was infamous for recycling everything to save money and resources. (Photograph by Walt Vielbaum.)

IN 1983, the forms are in place for construction of the new Powell and Market Street turntable, the third turntable at this location. The original Ferries & Cliff House Railway (Powell Street Railway) turntable had been in use since March 28, 1888, when Muni replaced it during May 1950. On November 23, 2002, Muni placed into service the fourth Powell and Market Street turntable, a $500,000 turntable that has extra ball bearings so it will turn easier. (Photograph by Walt Vielbaum.)

As part of any track construction project, the track has to be checked for proper gauge. One method Muni's contactor used was a single cable car truck with a grip. Not only would track gauge be assessed, but import clearances would also be determined, including the width of the slot. This photograph was taken in 1983. (Photograph by David Banbury.)

By mid-1983, the rebuilding of the Washington-Mason carbarn and powerhouse was well underway. The brick walls of the second Washington-Mason facility were retained, strengthened, and extended to enclose the storage yard ladder track area. The rebar is in place for the future pull-out gate track. When it became clear in the 1880s that reinforcement was needed in concrete construction, frayed cables from San Francisco's cable car companies were used. This lead to the design and patenting of rebar—the reinforcing steel that is still used in construction. (Photograph by Walt Vielbaum.)

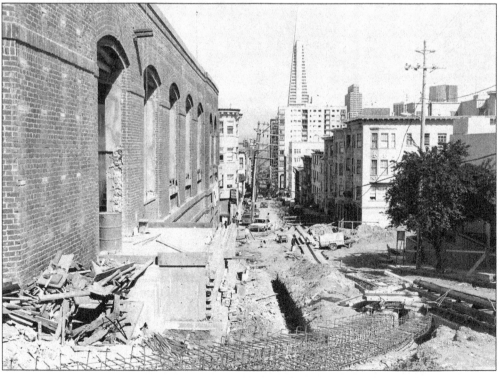

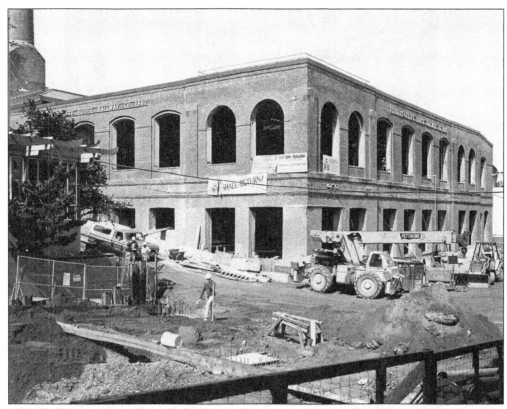

"We Shall Return!" proclaimed the banner hanging in 1983 on the now-gutted Washington-Mason cable carbarn and powerhouse, and the cable cars did. During this phase of construction, all trackage has been removed and replacement has yet to start. The carbarn walls had to be reinforced to keep them from collapsing, after it was discovered that the United Railroads, who built in 1907 the post-earthquake and fire facility, had not properly anchored the walls to the foundations. (Photograph by Walt Vielbaum.)

The lighter-colored brick (immediate left foreground) shows the wall extension to enclose the former open area, where cable cars are shunted to and from storage tracks. Although the building proclaims the "Ferries & Cliff House Railway Co. 1887," the only part of the facility that dates to 1887 is the smokestack, which originally rose 185 feet but was shortened to approximately 60 feet when, after the 1906 earthquake, a major crack was discovered in the upper part of the stack. (Photograph by Walt Vielbaum.)

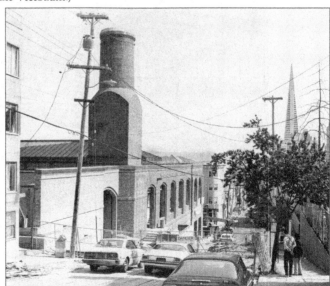

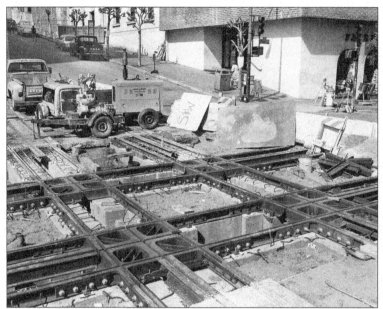

Pictured is the new track work associated with cable car crossing of the Powell Street cable car lines (the left-to-right tracks in this 1983 photograph) and California Street cable car. The crossing of two cable car lines is a complicated operation, as implied by the track work. One line's cable has to pass below the other line. Superiority is established by seniority. Since the Powell cable was built nine years after that of California cable, Powell cars coast across the crossing, while California cable cars remain attached to the cable. (Photograph by Walt Vielbaum.)

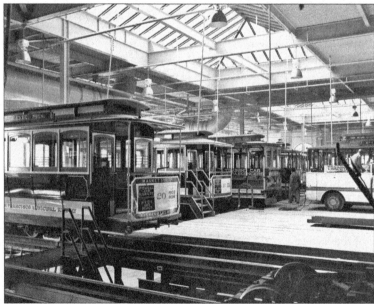

The new (post-1984) Washington-Mason cable car storage area features extensive skylights for improved lighting, maintenance pits, and facilities for car painting and body work. Unlike the former facility, Powell cars are stored with their fronts facing Mason Street. When it is time to go into service, cars are towed (sometimes pushed by manpower) out of the storage area and shoved to the Washington Street exit. (Photograph by Walter Rice.)

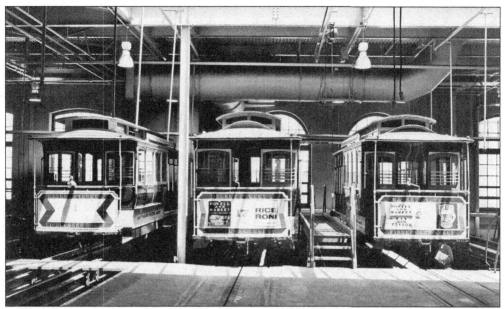

Powell cars Nos. 1, 17, and 25 rest over maintenance pits in the then new (in 1984) Washington-Mason cable car barn. No. 1 was built at Muni's Elkton Shops as the "Centennial Car" in 1973. No. 17 was constructed in 1887 by San Francisco's Mahoney Brothers, the general contractor for the original lines of the Ferries & Cliff House Railway. No. 25 was an identical car to No. 17, except that it has a wooden frame instead of a steel frame and was built by the F&CH Railway at Washington-Mason, 1888–1890. (Photograph by Walt Vielbaum.)

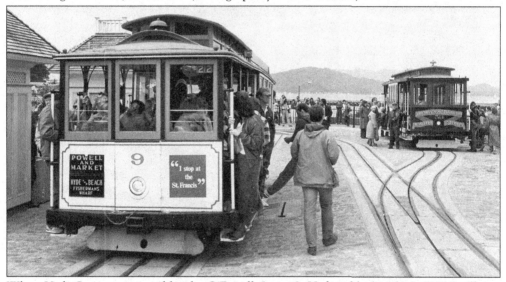

When Hyde Street was served by the O'Farrell, Jones & Hyde cable (until May 1954), all cars were double-ended, as was No. 53 (at right). With the opening of the Powell-Hyde line in April 1957, all service now was provided single-ended Powell Street combination cars. A turntable was constructed at Hyde and Beach Streets to reverse the single-ended cars. When the cable car system was rebuilt during the 1980s, a crossover was installed to enable double-ended cars once again to run to Hyde and Beach, as chartered No. 53 of the California Street line has done. (Photograph by Walt Vielbaum.)

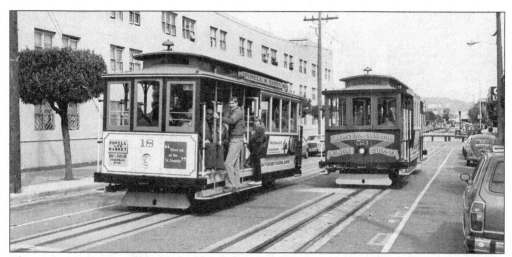

The passengers on Powell-Mason cable car No. 18 are unaware that a history-making event has passed them—California Street cable car No. 53 is first double-ended cable car at Bay and Taylor Streets. No. 53 was on a 1984 charter. Soon No. 53 will take the newly installed crossover to reverse directions. Muni had planned to install a crossover also at Powell and Market Streets. If the railway had done so, double-ended cars could have supplemented Powell Street single-ended combination cars on both Powell lines, since they both had outer terminal crossovers. (Photograph by Walt Vielbaum.)

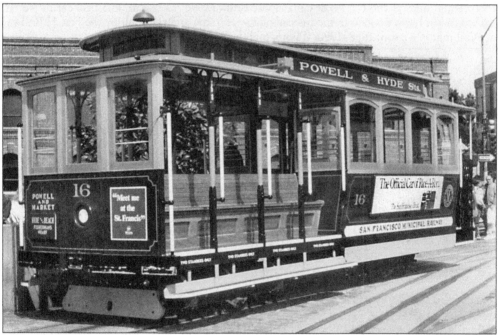

New No. 16 was dedicated on April 10, 1990. The car body was a product of Muni's Woods Division carpentry shop, and Muni's Pier 80 facility built the running gear. Only part of the roof was retained from the original car, first No. 16, (until 1973, numbered as No. 516), built by Carter Brothers in 1893–1894. No. 16 is painted in the blue and yellow colors that Muni used from 1939 to 1946 (two Powell cars in the 1940s were temporarily painted blue and yellow). No. 16 is at the Hyde and Beach Streets terminal of the Powell-Hyde cable. (Photograph by Walter Rice.)

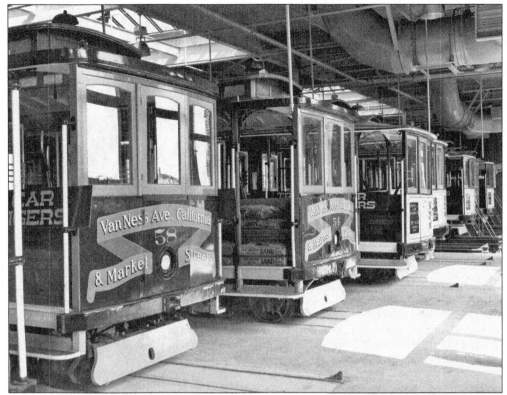

Lined up facing Mason Street in the Washington-Mason upper level car storage area are two double-ended California Street cars and five Powell Street single-ended combination cars, post 1984. Cal car No. 54 has bags of sand stacked on it. Sand is used to aid braking, particularly in rainy weather. (Photograph by Walt Vielbaum.)

On June 21, 1984, Powell Street cable cars decorated by radio stations K101 and KNBR pass at Powell and Pine Streets in celebration of the return of full cable car service, which had been shut down for rebuilding since September 1982. Earlier that month, smaller celebrations had been held for the return of California Street and Powell-Hyde cable cars. With the return of the Powell-Mason cable, San Francisco once again had full three-line cable car service. (Photograph by David Banbury.)

The KNBR-decorated cable car descends Powell Street after having crossed California, during the June 21, 1984 celebration of the "Return of the Cable Cars." The celebration began with a ribbon-cutting ceremony at Union Square, followed by a parade of cable cars up Powell Street, led by a U.S. Marine band. Twenty-six Powell cars had been rehabilitated during the 1982–1984 system rebuilding. (Photograph by David Banbury.)

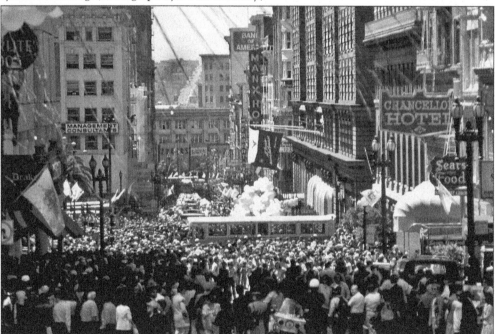

Does San Francisco love its cable cars? The huge crowd at Union Square for the "Return of the Cable Cars" celebration pronounces a resounding "Yes." An unloved Muni 2-Clement bus fights its way across Powell Street at Post. The rehabilitation was completed in June of 1984, in time for San Francisco's hosting of the Democratic Party's national convention that summer. The cable cars were back. (Photograph by David Banbury.)

The San Francisco tradition of cable car gripmen being photographed at the end of the line goes back to the late 1800s, when professional photographers would photograph cable car crews and return a few days later to sell their work. In May 2005, gripman Val Lupiz posed next to Powell-Hyde car No. 27 at that line's northern terminal, Freidel Klussmann Memorial Turnaround, Hyde and Beach Streets. Since gripping, Val has stopped his Hyde Street cable car at Lombard Street to allow a young man, to the delight of passengers and crew, successfully propose marriage. (Photograph by Walter Rice.)

When No. 5 returns to Powell Street, it will have a new front end. Only the roof and seats are from the original 1894 car. Since the late 1970s, Powell Street cable cars have been both rebuilt and newly built at the cable car carpenter shop at Muni's Woods Motor Coach Division, just east of Potrero Hill in the city. Cable cars are trucked to and from Woods and Washington-Mason. (Photograph by Val Lupiz.)

Construction of a brand new Powell Street car is well underway at the carpentry shop in 1990. The chassis, or underframe, of a cable car is made of steel and oak. High-quality plywood is used for the floor instead of tongue-and-groove pine, but almost everything else in the car is made of authentic materials. The frame, interior panels, doors, and seats are made of oak, with sheet-metal reinforcements on the sides and ends of the car. The roof is made of Alaskan yellow cedar laid over oak beams. While red oak is used for the chassis and the frame, white oak is used for the seats and the interior of the car. (Courtesy Walter Rice.)

Cable car No. 27—an 1887 product of the Mahoney Brothers, San Francisco, for the Ferries & Cliff House Railway and rebuilt by Muni in 1958—will soon be replaced by a new No. 27 that is under construction at the Muni's Carpentry shop in 2005. New No. 27's metal work, including the grips, trucks, and braking systems, is done at the cable car special machine shop at Muni's 700 Pennsylvania Avenue facility. Since Muni does not have a foundry, outside contractors make the metal parts, from the brass bells to the steel wheels. The patterns for the molds that are needed for the metal castings are made by Muni's pattern maker. (Photograph by Val Lupiz.)

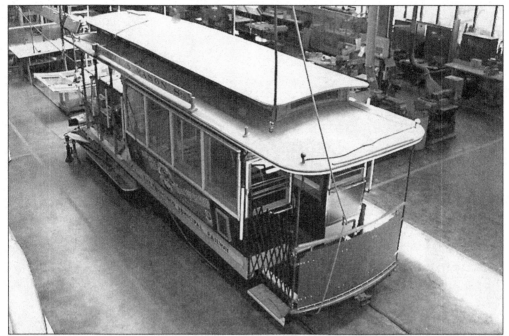

Powell Cable car No. 5, built by the Carter Brothers in 1893–1894 for the Market Street Railway's Sacramento-Clay cable car line extension for Golden Gate Park's 1894 Midwinter Fair, undergoes extensive rebuilding at Muni's carpenter shop in 2005. This is former No. 505's second extensive rebuilding; the first occurred in 1956 at Muni's Elkton shops. (Photograph by Val Lupiz.)

In the fall of 1984, Powell-Hyde cable car No. 23 coasts onto Washington Street to pick up passengers. The darker bricks date to 1907, but the lighter-colored bricks were newly erected during the 1982–1984 Washington-Mason car barn's rebuilding. The storage area ladder track area is now enclosed. Because of cable car ridership patterns, more cars are operated after the morning rush hour than during it. No. 23 is entering service at about 10 a.m. (Photograph by Walter Rice.)

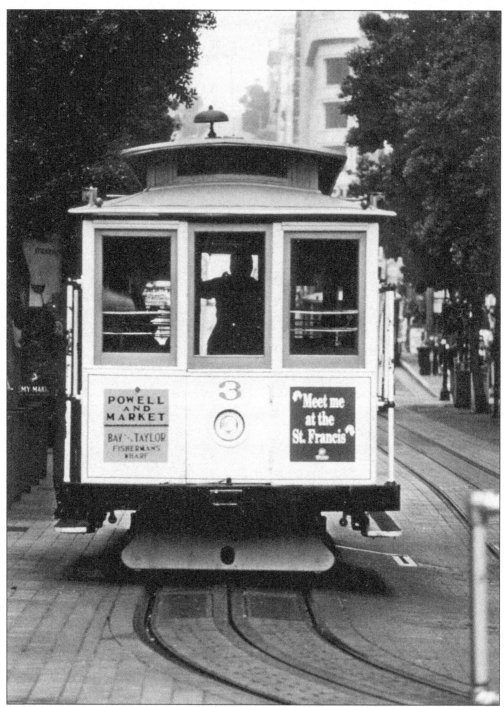

After the 1982–1984 system rebuilding, only car No. 3 remained in the pre-1982 cream and green Powell Street fleet colors. Except for cars specially painted in the colors of former Powell Street companies, all cars now sported maroon and cream colors reminiscent of the Powell Street Railway, the original operator of the Powell Street cable cars. Pictured in 1999, No. 3 is about to roll onto the Powell and Market Streets turntable. (Photograph by Walter Rice.)

Seven

TODAY'S POWELL STREET CABLE CARS/ROSTER

**Lines and Single-track Mileage
(equivalent to round-trip mileage), by line**
Powell-Mason: 3.2 miles
Powell-Hyde: 4.3 miles
Track Gauge: 3½ feet

Steepest Grades
Hyde between Bay and Francisco: 21 percent
Mason between Union and Green: 17 percent
Powell between Bush and Pine: 17 percent

Number of Operating Cars
28 Powell cars (19 in maximum service)

Cable
four 1¼" diameter cables
moving at 9½ miles an hour,
each powered by a 510-horsepower electric motor
in the cable car barn.

Cable Lengths
Powell cable: 9,300 feet
Mason cable: 10,300 feet
Hyde cable: 16,000 feet

Cable carbarn and Powerhouse
Washington and Mason Streets, 1201 Mason
Street. Originally built in 1887 for the Ferries &
Cliff House Railway. Rebuilt after the April 1906
earthquake and fire, and again rebuilt in 1982–
1984. Facility square footage: 84,741 square feet.

Today's Powell Street Cable Cars
single ended
27 feet, 6 inches long
8 feet wide
10 feet, 4¾ inches high
15,500 pounds
seated capacity 29, total capacity 60

•When Powell Street service resumed after
the 1906 earthquake and fire. Twenty-four
combination cars and three open cars that
were later rebuilt into combination cars
were used, all numbered in the 500 series.
The Powell cars were renumbered to their
present 1-28 series in 1973.

•"Carter Bros." cars were built in 1893–
1894 by the Carter Bros. Company for the
Market Street Railway of 1893–1902.

•"F&CH" cars were built in 1888–1890
at the Washington-Mason carbarn by the
Ferries & Cliff House Railway.

•"Mahoney Bros." cars were built in 1887
by the Mahoney Bros. Company for the
Ferries & Cliff House Railway. There is
evidence that they were the contractors
for the construction of the Ferries &
Cliff House Railway's tracks and cable
channels, and had the cars built under a
subcontract. "Muni" cars were built, on
the dates indicated, by the San Francisco
Municipal Railway. The cars are in the
standard Ferries & Cliff House Railway
paint scheme, except as noted. The F&CH
and Mahoney Bros. cars have Bombay
roofs (humps on both ends), the Carter
Bros. cars have standard roofs, and the
Muni cars also have standard roofs, except
as noted. The cars built prior to the 1982–
1984 Cable Car System Rehabilitation
Program received a major overhaul at
that time.

1	Muni	Built using the roof and seats from the first No. 506, a Carter Bros. car. Presented to the public at a ceremony on July 19, 1973, its paint scheme is more ornamented than the standard Powell-car paint scheme. The car has a plaque honoring Mrs. Klussmann. Extensive rebuilding completed in 1997.
2	Carter Bros.	Former No. 502. Extensive rebuilding in 1971.
3	Carter Bros.	Former No. 503. Mini's former green and cream paint scheme. Extensive rebuilding in 1955.
4	Muni	Presented to the public at a ceremony at Powell & Market on September 15, 1994. New No. 4, like its predecessor, a Mahoney Bros. car, has a Bombay roof.
5	Carter Bros.	Former No. 505. Extensive rebuilding in 1956. Rehabilitation work was done in 2002.
6	Carter Bros.	Formerly the second No. 506. Rebuilt in 1965 from the first No. 518, a Carter Bros. car. (The first No. 506 was scrapped, except for the roof and seats; see car No. 1.)
7	Carter Bros.	Former No. 507. Extensive rebuilding in 1957. It was the first test car on the Powell-Hyde line, in March 1957.
8	Carter Bros.	Former No. 508. Extensive rebuilding in 1958.
9	Muni	Entered service on April 24, 2000. Green and white paint scheme similar to the colors of the Market Street Railway (1921–1944).
10	Carter Bros.	Former No. 510. Extensive rebuilding in 1960. Rehabilitation work was done in 2002.
11	Carter Bros.	Former No. 511. This was the first car rebuilt at Mini's Woods carpenter shop, in 1977.
12	Carter Bros.	Former No. 512. Extensive rebuilding in 1959. It was exhibited in Japan in 1987.
13	Muni	Entered service on September 19, 1991; dedicated on Dec. 5, 1992. Dark green with red-trim paint scheme similar to the colors of the United Railroads (1902–1921).
14	Muni	Formerly the second No. 514. Entered service in late January 1964.
15	Carter Bros.	Former No. 515. Rebuilt in 1954.
16	Carter Bros.	Almost entirely rebuilt by Mini, with only part of the roof retained from the original car (former No. 516); dedicated on April 10, 1990. Painted in Mini's former blue and yellow colors (1939–1946).
17	Mahoney Bros.	Former No. 517. Extensive rebuilding in 1956.
18	Muni	Formerly the second No. 518. Entered service on July 4, 1962. It was built almost entirely new, except for some spare parts, to commemorate Mini's 50th anniversary in 1962.
19	Muni	Built almost entirely new, except for some metal work. It was dedicated on October 7, 1986.
20	Carter Bros.	Former No. 520. Ridden by Humphrey Bogart in the movie *Dark Passage*. Extensive rebuilding in 1968.
21	Muni	Dedicated on December 5, 1992.
22	Mahoney Bros.	Former No. 522. Extensive rebuilding in 1956.
23	F&CH	Former No. 523. Extensive rebuilding in 1970.
24	Mahoney Bros.	Former No. 524. No. 524 was operated at the Chicago Railroad Fair in 1949. It made the last trip on the Washington-Jackson line, on September 2, 1956. Extensive rebuilding in 1958.
25	F&CH	Former No. 525. Extensive rebuilding in 1976.
26	F&CH	Former No. 526. Extensive rebuilding in 1973–1975.
27	Mahoney Bros.	Former No. 527. Extensive rebuilding in 1958.
28	Muni	Entered service on January 2, 2004. New No. 28, like its predecessor, a Mahoney Bros. car, has a Bombay roof.

SOURCE: Robert Callwell and Walter Rice, *Of Cables and Grips: The Cable Cars of San Francisco*, second edition, March 2005.

For those interested in cable cars—their history and operations not only in San Francisco but around the world, the most comprehensive cable car Web site is "The Cable Car Home Page." The site is updated, with new materials monthly:

www.cable-car-guy.com

Visit us at
arcadiapublishing.com

......................................